IMAGES
of America

EARLY CARSON CITY

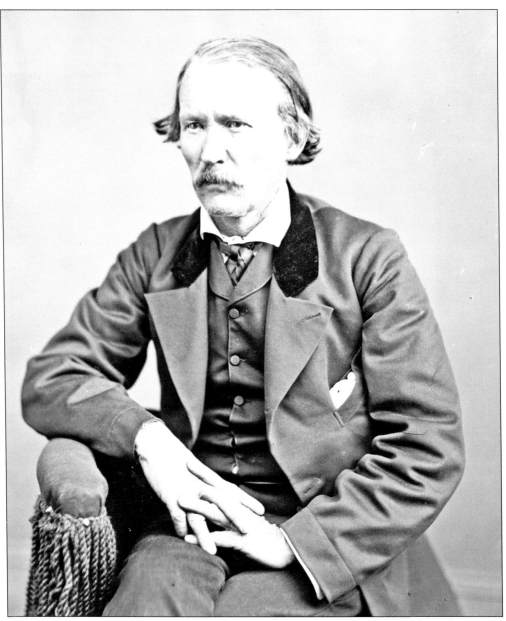

Christopher "Kit" Carson led explorer John C. Fremont on expeditions, one through Nevada, where the Carson River was named for him. In 1858, when Abraham Curry was looking for a name for his new city in Eagle Valley, he decided to name it Carson City. (Library of Congress.)

ON THE COVER: These young bicyclists stopped to pose for their picture on a warm spring day in 1903. The mountain range behind them mirrors a view looking north from the racetrack in Carson City. Bicycles became a major source of transportation in Carson City beginning around 1886. (Pat Cuellar.)

IMAGES
of America

EARLY CARSON CITY

Susan J. Ballew and L. Trent Dolan

ARCADIA
PUBLISHING

Published by Arcadia Publishing
Charleston, South Carolina

Printed in the United States of America

Library of Congress Control Number: 2009931120

For all general information contact Arcadia Publishing at:
Telephone 843-853-2070
Fax 843-853-0044
E-mail sales@arcadiapublishing.com
For customer service and orders:
Toll-Free 1-888-313-2665

Visit us on the Internet at www.arcadiapublishing.com

To our dad, William M. Dolan, journalist for the Nevada Appeal
for 60 years. Sometimes known as "Wild Bill" or "Mr. Carson
City," he wrote Pages from the Past, the longest continuous
daily column in the state. He often talked to us about writing
a book, so here's to you, dad: the stories you told us about in
Pages from the Past and the photographs to go with them.

Abraham Curry, one of Carson City's
founders, after finding Genoa too
expensive, said, "Well, I'll build a city
of my own," and according to Thomas
H. Thompson and Albert Augustus
West, publishers of History of Nevada
in 1881, "Before the sun had set into
the lap of the west, he was in Eagle
Valley for the purpose of redeeming
his promise." (Susan J. Ballew.)

CONTENTS

ACKNOWLEDGMENTS

There are many people to thank for their assistance with this project. The most important one is our mother, Dorothy Fendrich Dolan. We thank her not only for the use of her collection of photographs but also for her wisdom, drive, and support for this book and for her endurance as participant in time-traveling with our dad, Bill Dolan. Thank you to Ron James, state historic preservation officer; Jeff Kintop, state archivist; Guy Rocha, state archivist (retired), and Joyce Cox, librarian, Nevada State Library and Archives; and to Debbie Seracini of Arcadia Publishing, our very patient editor. Thanks to the *Carson Morning Appeal* editors of the past, Henry Rust Mighels and Sam Davis, for writing all the wonderful news stories that have become part of our history. Many thanks to the following members of the community for their support and donations of privately owned photographs: Dorothy Dolan, Pat Cuellar, Rolf and Gloria Johnson, Cindy Southerland of Southerland Studios, Bill and Dottie Kelley for use of the Leisure Hour Club photographs and the Vanderlieth *Crazy Scrapbook*, Bonnie Nishikawa, Bud Klette for Gayle Klette's postcards, Jim and Mae Thorpe, Reno Consolidated Coin, and Bernie Allen. Thanks also to the Carson City Historical Society, Nevada State Library and Archives, Nevada Historical Society, Nevada State Railroad Museum, Comstock Historic District Commission, Bancroft Library of the University of California, and the Library of Congress. And thanks most especially to Gary Ballew, Susan's husband, whose wisdom and guidance has helped us through it all.

INTRODUCTION

In 1860, Carson City's newspaper, the *Territorial Enterprise*, was printed in the Ormsby Building on Carson Street between Second and Third Streets. Carson City was being built "as fast as lumber could be procured." Carson City, Carson County, Utah Territory, was off to a galloping start.

In May 1860, the reality of being pioneers struck home with the death of Maj. William M. Ormsby in the Pyramid Lake War. Major Ormsby's brother, Dr. John S. Ormsby, wrote the following in a letter to Margaret, the major's wife: "Dear Sister: I am well, we arrived safe on Truckee. One of the greatest things for you, my dear sister, is the discovery of the Major's remains. This day we are burying his remains with military honors. The Carson City Guards, and others together with two companies of regulars conducted the ceremonies to do honor." Carson County was renamed Ormsby County in recognition of Ormsby's sacrifice in battle.

During the war, which pitted settlers against Northern Paiutes, residents scurried to the closest structure for protection throughout the Carson Valley. Forces from Placerville and Sacramento reported that "Arms and ammunitions are on their way here as fast as possible." People were guarding their lives by building forts for safety. Mining was suspended, and even the Pony Express was interrupted. In Virginia City, women and children stayed in an unfinished stone house later called Fort Riley, and in Carson City, the Penrod Hotel became a fortress. Carson County folks were hoping that a political structure and statehood would provide them protection from future harrowing events.

Nevada became the 36th state on October 31, 1864. A proclamation came via telegraph from Washington, D.C., on October 30, 1864, to Nevada governor James W. Nye, to the attention of Secretary of State Orion Clemens (Mark Twain's brother), stating "That I, Abraham Lincoln, President of the United States in accordance with the duty imposed upon me by the act of Congress aforesaid do hereby declare and proclaim that the said state of Nevada is admitted into the Union."

Carson City became the capital, and the planning for a community began. The state capitol building was designed by Joseph Gosling, built by Peter Cavanaugh, and completed in 1871 from

locally quarried sandstone. It was a grand building with an impressive dome that could be seen throughout the city. The year before, in 1870, the U.S. Mint was built, and about that time, the Virginia and Truckee Railroad became the main source of transportation.

In the early days, Carson City had a different view of downtown. King's Canyon, west of the city, had been the site of a resort, and King Street became a main thoroughfare. The Carson Brewery was located at the corner of King and Division Streets, and the brewing of beer became a mainstay of our pioneer citizens. From the capitol building, King Street and King's Canyon with the road climbing westward into the Sierras all the way to Spooner Summit and Glenbrook on Lake Tahoe were visible. The canyon was the site of intense logging, with flumes, first constructed by Yerington and Company in 1869, being used to transport the logs to the Monitor Mill at the base of the Sierras. In 1919, the King's Canyon Road became part of Lincoln Highway.

The community grew, and schools and opera houses were built. Entertainers came to town and even an occasional circus. In 1903, Teddy Roosevelt, the "hero of San Juan," came to Carson City. Our people knew how to decorate the city and honored the president with a parade—the whole community became involved.

This book is a glimpse at the early people who lived in Carson City and their everyday lives. It is not so much an attempt to be a historical document of important dates and buildings as it is an effort to provide a glimpse of the people that walked the streets, cooked the meals, built the buildings, delivered the mail, and made Carson City a unique pioneer community. Through the years, life has continued in our little town at the foot of the Sierra Nevada. The whirl of history continues in a maze of important events outside of the little bubble, but Carson City continues on the same path as a people living in a collection of days, hours, and minutes.

So when looking at the pictures, try not to look so much at the costumes, the events, or where the buildings are, but instead look at the people through their eyes. Put yourself in their shoes, imagining what it felt like to live on dirt streets and ride the rails to Virginia City, or take a stagecoach to Lake Tahoe, or to sail the lake on a warm summer day. Feel the breeze as a thunderstorm builds, or hold on to the fence at the capitol grounds as a Washoe zephyr breezes through. Walk with our ancestors as they go to church on Sunday, make a bet at the racetrack, or climb onto a stagecoach and ride with Hank Monk to Bodie. Stand at the train depot as the Virginia and Truckee Railroad car arrives, just to see who steps off. Watch the circus workers as they pitch the big top next to Saliman Road. Listen for the bell from the Warren Fire Engine Company. Watch for the governor as he strolls down King Street on his way to work.

Carson City really has not changed much through the years. We have not changed so much either. But what has changed is how we see the world and how much more important it is to see Carson City as it was.

Authors Sue Ballew and Trent Dolan have been writing Past Pages, following in their father's footsteps, since 2006. *Early Carson City* journeys through the past from 1860 to 1930. Today people take many risks, but the pioneers took risks too—with their lives.

Each photograph of Carson City is unique in its own respect. So whether you live in Carson City or are a visitor, we hope that you will enjoy looking at the scenes and putting yourself in them. You may ask what the day was like. Is that looking west or east? Are those roads all paved? We hope you enjoy looking at the photographs as much as we've enjoyed collecting them to share with you. Some call it time traveling or researching the past. Whatever you want to call it, enjoy your journey.

One

EARLY MEMORIES

The Great Seal of the State of Nevada is pictured in "The Wheeler Survey," published in *Harper's New Monthly Magazine* in 1877. The seal shows the reduction works and the silhouette of a man propelling a carload of ore "along the trestle works" as the sun shines over the mountains in the background. Note that smoke from the smokestack on the train and the smoke coming from the mill chimney are blowing in different directions. This was changed in later versions of the seal to reflect the wind blowing in the same direction. (Susan J. Ballew.)

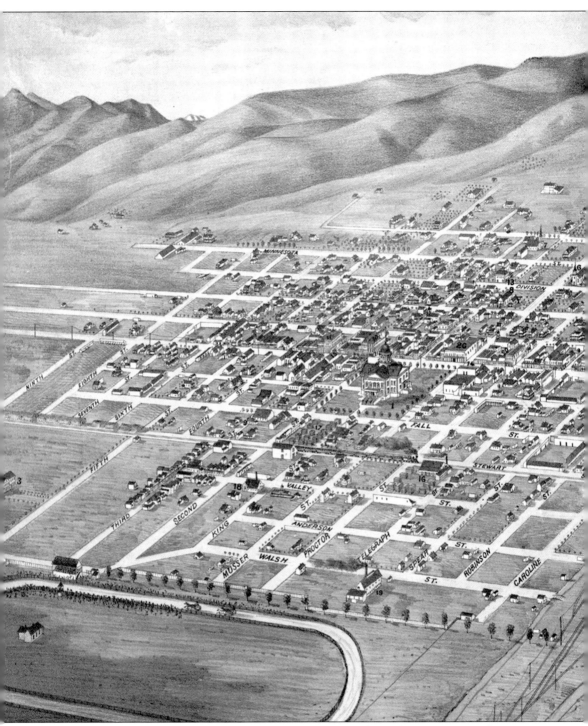

An 1875 bird's-eye view of Carson City (population 3,222), drawn by Augustus Koch, an army-trained cartographer, shows Carson City nestled on the eastern side of the great Sierra Nevada. Now a major tourism and commercial center for the Great Basin, Carson City encompasses a land area of 168 square miles, making it geographically one of the country's largest state capitals,

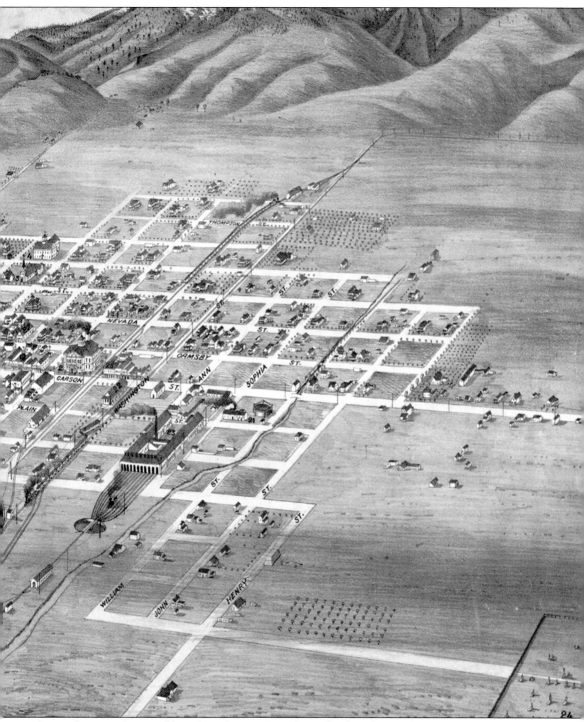

but with a population of less than 56,000. Significant landmarks are the state capitol with its dome in the center, the racetrack (bottom left), the Virginia and Truckee (V&T) engine house (bottom right), and the Foreman-Roberts House three blocks right of the V&T engine house on the east side of Main Street. (Bancroft Library, University of California.)

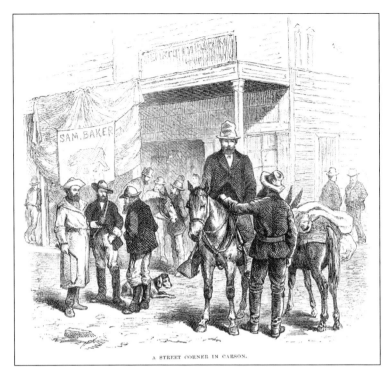

A STREET CORNER IN CARSON.

Carson City, the capital of Nevada, was named after Kit Carson, the celebrated pathfinder who first crossed the Sierras in 1833. Carson City was characterized as a busy city of about 4,000 with home-like qualities, but which, according to "The Wheeler Survey" in *Harper's New Monthly* magazine in 1877, "bends now and then into a suspicious corner . . . where the evil appearing saloon is an almost unavoidable adjunct." (Susan J. Ballew.)

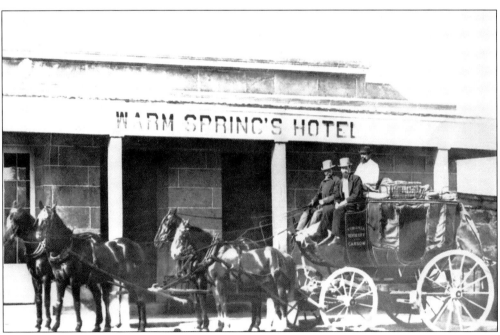

Built of hand-hewn sandstone in 1860, the Warm Springs Hotel was owned and operated by Abe Curry. It was the site of the first territorial legislature in 1861 and in 1864 became the state prison. Although no names of people are provided, the stage driver appears to be the famous Hank Monk. (Nevada State Library and Archives.)

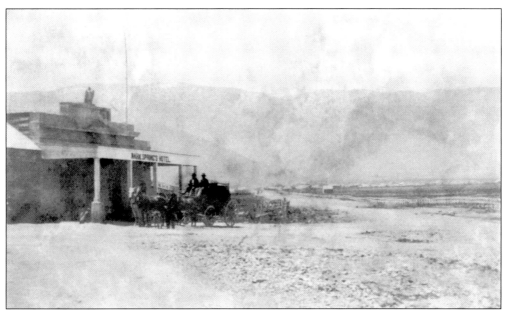

Lots in Carson City were freely given away to parties who could build on them, and some were traded off. "A fourth-interest in Warm Springs was sold to Mr. Curry for a pony," making Abraham Curry sole owner, according to Thompson and West. There are many photographs of the Warm Springs Hotel and the stage pulling up. This one shows the desolate landscape with the tiny town of Carson City to the west. Curry had great vision when he started his Warm Springs Hotel. There were no water pipes providing water in the early days, and placement of buildings was solely reliant on what was available, in this case the hot springs. An advertisement for the Warms Springs Hotel touts its "warm swimming baths, . . . Elegant breakfasts, luncheons and dinners." (Above, Library of Congress; below, Nevada State Library and Archives.)

697. Carson Street, from the Plaza, Carson City.

One of the earliest known photographs of Carson City is shown here. When Mark Twain arrived in Carson City in 1861, he said in *Roughing It*, "It nestled on the edge of a great plain and was a sufficient number of miles away to look like an assemblage of mere spots. . . . It was a wooden town; its population 2,000 souls . . . [with] four or five blocks of little frame stores . . . [and] the sidewalk was of board. In the middle of town, opposite the stores, was 'the Plaza.'" (Library of Congress.)

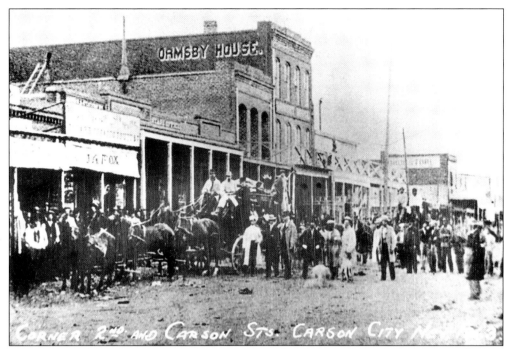

In 1863, before Nevada was a state, a group poses with a stagecoach hitched to a team of horses. Koppel and Platt's clothing store is on the far left, and the original Ormsby House, built in 1862, is pictured standing above all in the background. John G. Fox also had a business along Carson Street and carried the largest stock of various lines in Nevada, which included school books and supplies, a library of books, and miscellaneous items. He had one of the few fireproof buildings. The Ormsby House with John T. Pantlind, proprietor, stands majestically below along with Doc Benton's and Clugage's line of stages. (Above, Nevada State Library and Archives; below, Nevada State Library and Archives.)

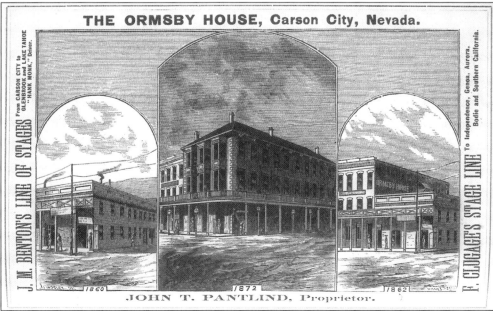

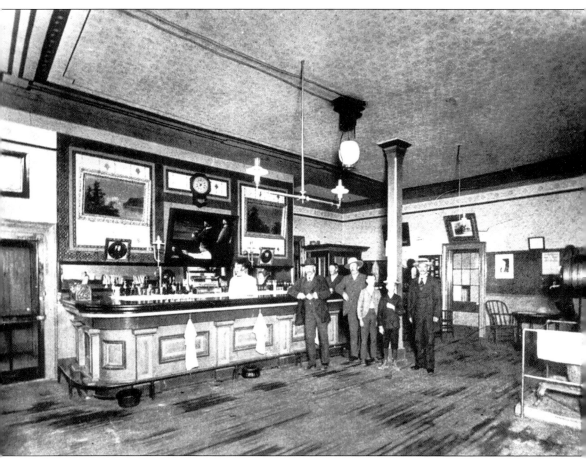

After the death of Hank Monk, the famed stagecoach driver, some claimed that his ghost would appear drinking beer in a chair near the potbellied stove inside the old Ormsby House, as told in the *Carson Morning Appeal.* The old chair in the back corner was probably Hank's. (Nevada State Library and Archives.)

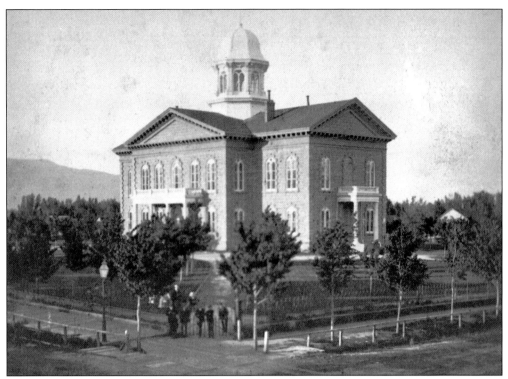

This half of a stereo card depicts the capitol in Carson City shortly after its completion in 1871, showing young trees and the wrought-iron fence built as a result of a contract to a schoolteacher named Hannah Clapp. (Susan J. Ballew.)

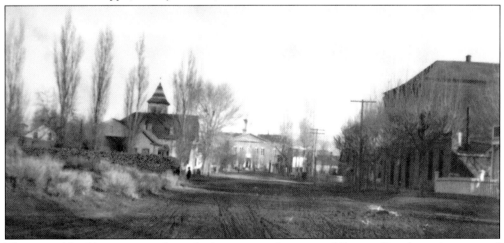

The capitol building appears through the trees in this view of Carson City from the unpaved King Street, which was the main thoroughfare to Glenbrook at Lake Tahoe. According to Dan DeQuille in *Comstock Mines*, Glenbrook is situated on the east side of Lake Tahoe. It was once the location of the Yerington, Bliss, and Company sawmills. The narrow-gauge railroad carried lumber to the top of the mountain flumes and floated the lumber to Carson City. On the right is the Carson Brewery, and on the left is the Presbyterian church. King's Canyon lies at the western end of this road and was named after B. L. King, who came to the valley in 1852 and established a resort. He settled here with his daughters. (Southerland Studios.)

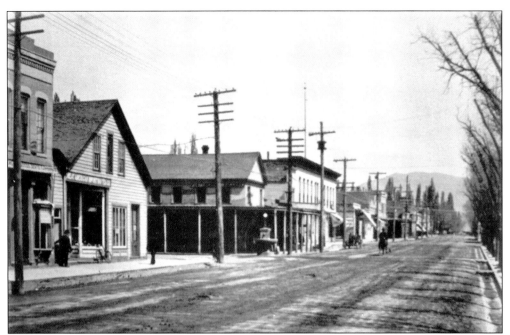

Herman Lee Ensign was an animal rights activist from the New York Humane Alliance. His life was dedicated to the welfare of animals. He had planned to furnish a fountain in every state capital in the United States. Carsonites had anticipated the fountain's arrival for many months. The fountain was placed in the middle of King Street (the first street on the right, above) and dedicated by Mayor H. B. van Etten on Labor Day, 1909. Pictured below, the public fountain has since been moved farther from the capitol building and closer to the Nevada Supreme Court Building on Carson Street. The fountain was used to provide water for people, horses, and dogs. (Above, Bernie Allen; below, Nevada Historical Society.)

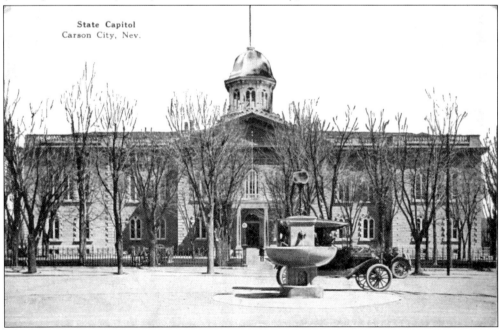

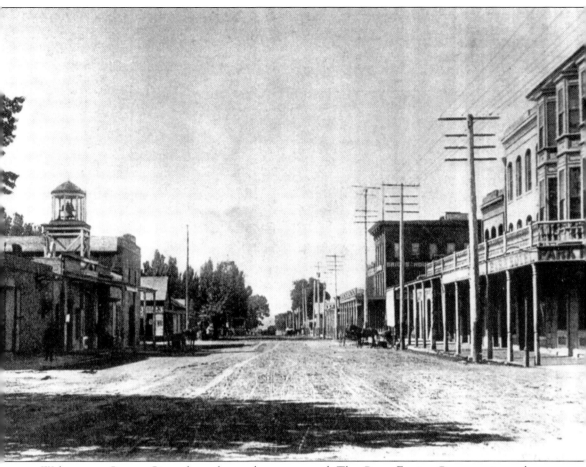

Welcome to Carson City, where the roads are unpaved. The Curry Engine Company is on the left and stands out with its bell tower. The fire brigade was comprised of volunteers who manned two fire engine stations, the Curry and the Warren Engine Company. The fire bell would ring, and men throughout the community would run out of their homes and businesses to help fight the fire. "Doc" Benton's stables are on the left. (Bernie Allen.)

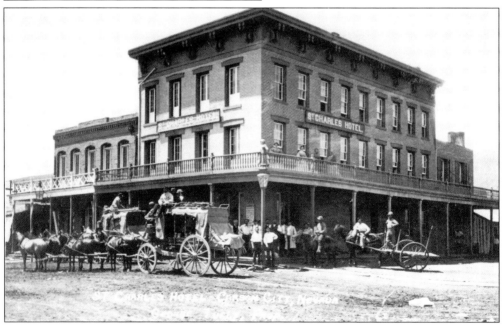

St. Charles Hotel

GEO. TUFLY, Proprietor.

CORNER OF CARSON AND THIRD STREETS,

CARSON CITY, NEVADA.

FIRST CLASS HOTEL.

THE BUILDING IS A THREE-STORY FIRE-PROOF BRICK,

With all the Modern Improvements.

The Proprietor of this

WELL-KNOWN HOTEL

Spares no pains in making his Guests Comfortable.

The St. Charles Hotel had many owners, including George Tufly. The building, according to the V&T Railroad Directory advertisement, is "three story fire-proof brick." Still standing on the corner of Carson and Third Streets, it is one of the city's oldest landmarks. (Nevada State Library and Archives.)

A Concord stage awaits passengers in front of the St. Charles Hotel, which was built in 1862 by George M. Remington and Daniel Plitt, with brickwork by T. T. Israel. It is the oldest hotel in Carson City and has had many owners, one of whom was George Tufly. There were 48 guest rooms, an office, a reading room, and a parlor on the second floor. The hotel was lighted in 1898 with gas and electricity and is still in use today. (Nevada State Library and Archives.)

J. M. Benton Livery and Sale Stable, on the corner of Carson and Third Streets, was the location of the Lake Tahoe Stage Office. (Nevada State Library and Archives.)

J. M. BENTON
LIVERY AND SALE STABLE

Corner of Carson and Third Streets,

CARSON CITY, - NEVADA.

LAKE TAHOE STAGE OFFICE

Parties visiting Lake Tahoe will save money by purchasing **Through Tickets,** which can be procured at the offices of the Virginia and Truckee Railroad Co., in Virginia, Gold Hill and Carson; also at J. M. Benton's, and at the Ormsby House, Carson, and at the Truckee Hotel, Truckee, California.

SAM MILLER, - - - Agent,

No. 2 New Montgomery St., San Francisco.

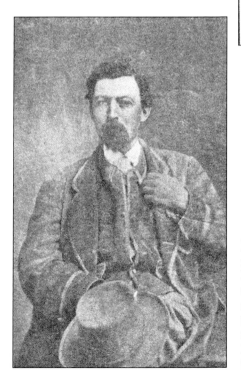

Hank Monk was born on March 24, 1826, in Waddington, New York, and always had a love for horses. He came out west in 1852 and continued his career as a stagecoach driver. His most famous passenger was Horace Greeley, remembered for his advice of "go west, young man." Hank Monk drove stages for more than 20 years between Carson City and Glenbrook for "Doc" Benton. (Susan J. Ballew.)

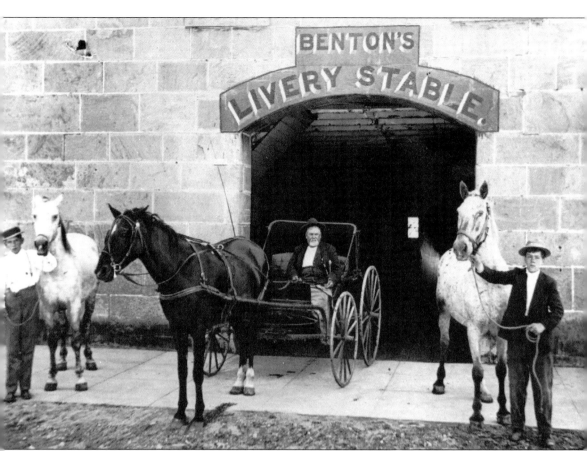

Benton's Stables were on the corner of Carson and Third Streets. "Doc" Benton began his business in Carson City with a livery stable and was proprietor of the stage line between Carson City and Lake Tahoe. He was employer of the famous stagecoach driver Hank Monk, also called "Whip." "Doc" Benton was born in Tompkins County, New York, in 1837 and served in the military as a surgeon until 1864. He resigned because of poor health and began his business in Carson City. (Nevada Historical Society.)

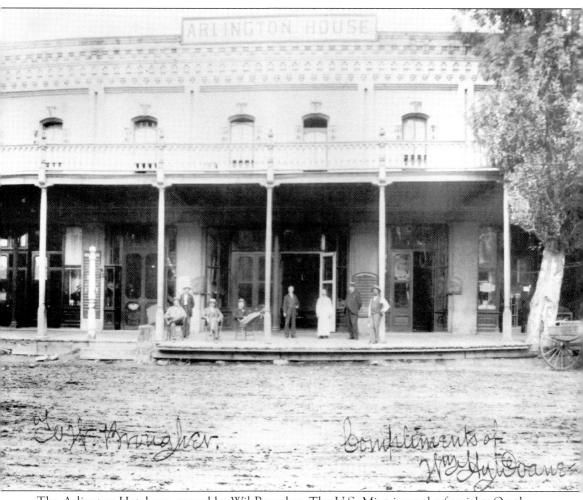

The Arlington Hotel was owned by Wil Brougher. The U.S. Mint is on the far right. On the porch, the last person on the right is an African American by the name of Billie Lynch, who came to Carson City with Abe Curry in 1866 to work at the mint as a porter. Billie witnessed the assassination of Abraham Lincoln in 1865 and was a valet to Pres. Andrew Johnson. (Nevada Historical Society.)

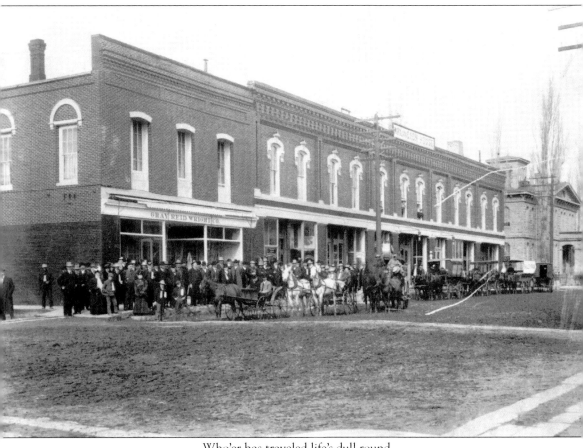

Who'er has traveled life's dull round,
Wher'er his stages may have been,
May sign to think he still has found,
The warmest welcome at an inn.

—*Carson Morning Appeal*, 1896

The Arlington House was rated as a premier lodging establishment. It held 65 guests and had an office, reading room, bar, and billiard room. It was run by R. Grimms with the assistance of Hy Doane. The building on the same block to the left is Gray, Reid, Wright, and Company. (Nevada Historical Society.)

Two

BUILDING OF A COMMUNITY

No matter what drew people to live in Carson City, they enjoyed all of the events. Here a little girl poses for the photographer while her mother tends to the baby in the carriage on the grounds of the state capitol in the early 1900s. (Carson City Historical Society.)

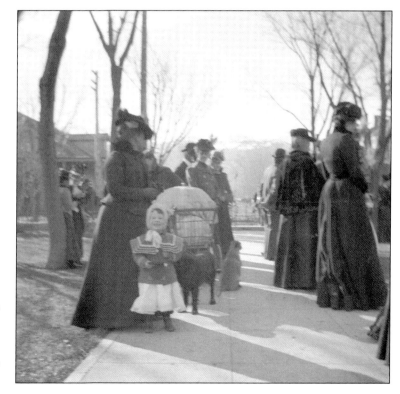

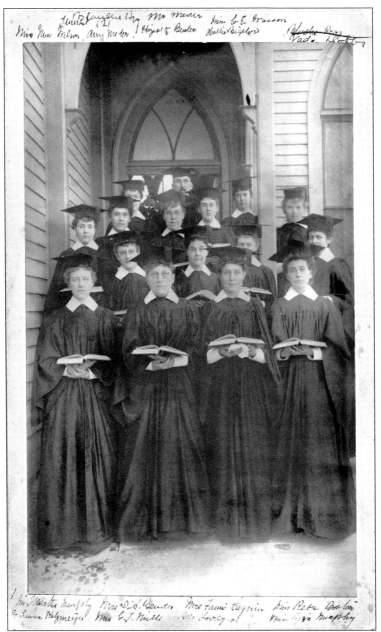

St. Peter's Episcopal Church, located on the corner of Telegraph and Division Streets, had its beginnings in 1863, when William Maxwell Reilley founded the parish, and the church was established with wardens and vestrymen. The St. Peter's Parish Register recorded that "The Wardens were Messrs S. D. King and A. H. Griswold, with Governor Jas. W. Nye, Judge Geo. Turner, Dr. A. W. Tjader and Messrs H. F. Rice, H. M. Yerington, J. Dorsey and P. W. Van Winkle as Vestrymen." In 1870, the first vested choir in the state was organized. The organist was John P. Meder (back row, right), with Mrs. D. A. Bender (back row, left) the leader. The photograph taken by Rev. J. N. Weyslop. The Kitzmeyers, Meders, Wassons, Mills, Benders, Cagwins, and many of Carson City's early residents were members of St. Peter's Episcopal Church. (Nevada Historical Society.)

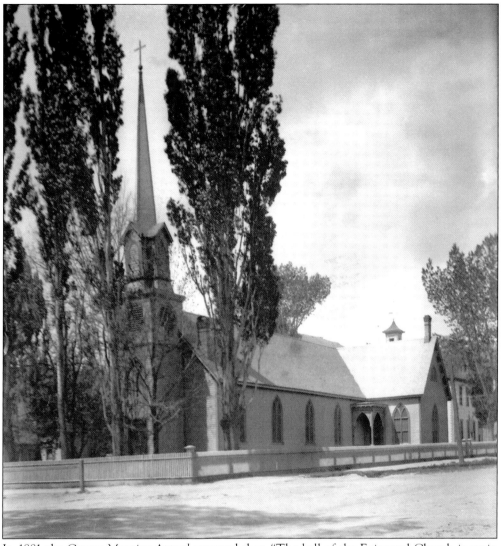

In 1881 the *Carson Morning Appeal* reported that, "The bell of the Episcopal Church is again so badly cracked that it no longer is of any use in calling sinners to the sanctuary. . . . It cracked Sunday morning from excessive cold." The bell was repaired at the Virginia and Truckee shops, and as a result, the *Carson Morning Appeal* published the following:

> And after the hanging its regular clanging
> was bid the worshipers bend the knee.
> In spire of St. Peters
> T'will sound the sweeter
> Than the shops of the V & T.

St. Peter's Episcopal Church was constructed in 1867 by the Corbett brothers. The King David window was made over 150 years ago and shipped from a parish in England named St. Peter's. In 1868, the Reverend George B. Allen sailed from New York to become the church's new rector. St. Peter's is the oldest church in Carson City and is still in use today with the original sanctuary. (Pat Cuellar.)

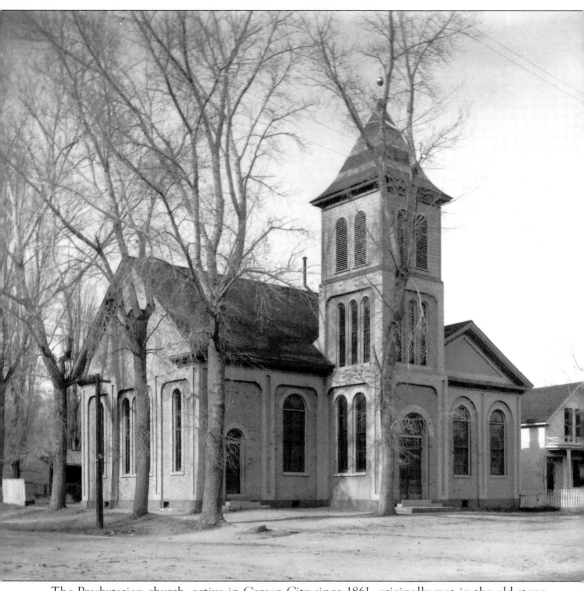

The Presbyterian church, active in Carson City since 1861, originally met in the old stone schoolhouse with Rev. W. W. Briar. Church construction began in 1862 and was completed in 1864 at King and Nevada Streets. Mark Twain helped raise $100 to complete construction by donating proceeds from his first series, called the "Third House." Mark Twain's brother, Orion Clemens, was married to Molly Clemens, and both were active in the church. Their daughter, Jennie, was saving money to purchase a Bible for the pulpit when she died from Rocky Mountain spotted fever. The congregation funded the remainder of the Bible, which is still a treasured historic possession. Beginning in 1929 and continuing through the Depression, the church became federated with the First Methodist Church. In 1936, the old wooden belfry was dismantled, as it was too expensive to maintain. Today only the brick portion of the belfry remains. (Pat Cuellar.)

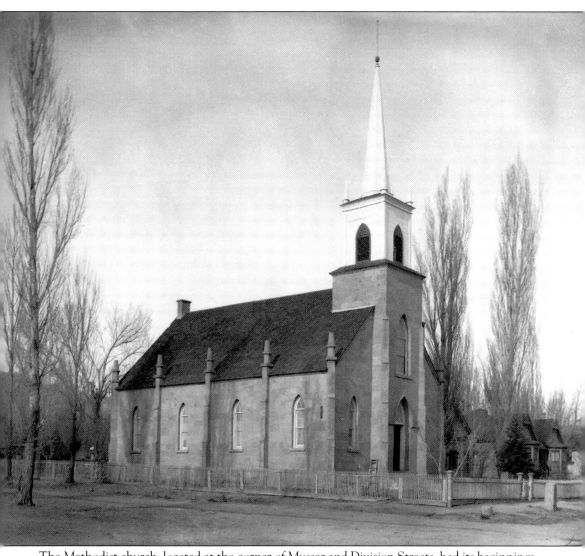

The Methodist church, located at the corner of Musser and Division Streets, had its beginnings in 1859, when Jessie Bennett conducted services at Eagle Ranch. The church was dedicated in 1867. In 1874, Sam Davis wrote about Jessie Bennett, the Methodist preacher who traveled a 200-mile circuit: "Many is the time we have seen this brave cheerful little man's plug hat looming up from the springless seat of the stone laden mule carts." According to the *Territorial Enterprise*, "so earnest, did this heroic clergyman address himself to the building of his church that the people stood by him with all possible and needed financial help." The Methodist church also lost its steeple in the 1930s. (Pat Cuellar.)

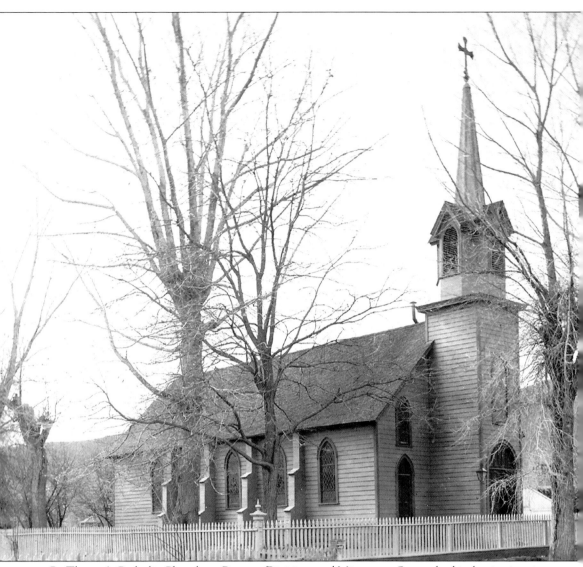

St. Theresa's Catholic Church on Proctor, Division, and Minnesota Streets had its beginnings in 1860 and, according to Thompson and West, "was blown down in a hurricane, and the lumber taken away by those who had a claim for wages." In 1865, it was rebuilt by Fr. John Curley. The church was covered with brick in 1900, as the wooden structure was still unstable. In early 2000, the church was relocated to 3000 North Lompa Lane, and old St. Theresa's became the property of the Brewery Arts Center. In *Roughing It*, Mark Twain described the powerful wind in Nevada called the Washoe zephyr. "It blows flimsy houses down, lifts single roofs occasionally, rolls up tin roofs like sheet music." (Pat Cuellar.)

Abe Cohn's Emporium marketed the famous Dat-So-La-Lee baskets. Abe Cohn had settled in Carson City in 1882 and opened a mercantile and clothing store. Note the wooden boardwalks and muddy streets. (Southerland Studios.)

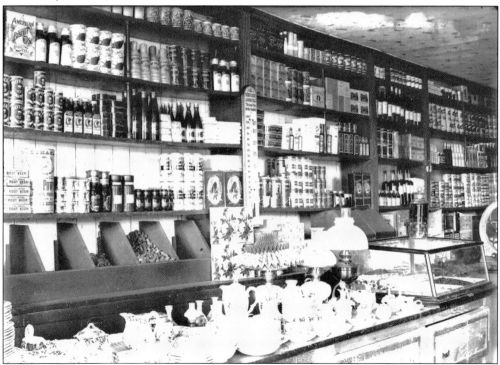

Abe Cohn's store shelves were stocked with everything an 1800s home might need, such as flour, tea, coffee, and dried fruit, as well as tools, glass, lamps, lanterns, medicine, boots, and clothing. (Southerland Studios.)

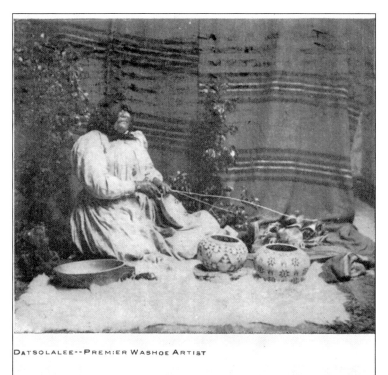

DATSOLALEE--PREMIER WASHOE ARTIST

Smith & Co.--Carson City, Nev.

Dat-So-La-Lee, a Native American woman of the Washo tribe, was born about 1835 near Genoa, Nevada. Abe Cohn saw her beautiful work and brought her to Carson City. According to *Dat-So-La-Lee, Washoe Indian Basketmaker,* by Dixie Westengard, her finest basket, "a myriad of stars to shine over [her] ancestors," had 56,590 stitches. In 1904, Abe Cohn took her to the Arts and Crafts Exposition in St. Louis, Missouri. The last 30 years of her life were devoted to making exquisite baskets for Abe. (Southerland Studios.)

Dat-So-La-Lee was caught between two worlds—she needed money to live, but she still abided by the rules of her world. She had inherited the right to make ceremonial baskets from her mother and was trained by the older women of the village to gather and prepare from birch, fern, and willow. (Library of Congress.)

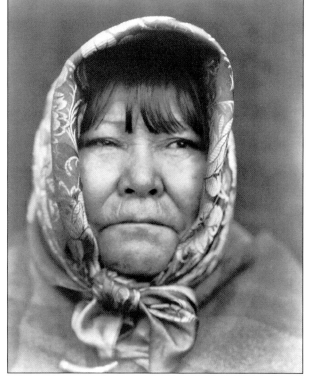

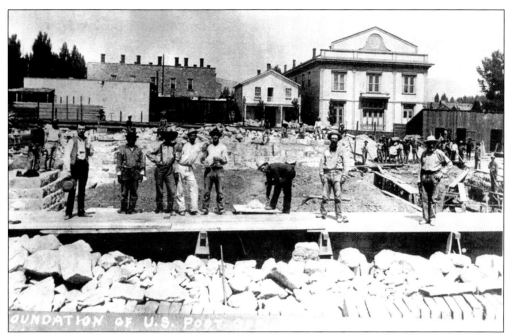

Laying the foundation of the federal building (Carson City Post Office) took place in 1898. In the background are the Virginia and Truckee flatcars with material to be used in construction. To the right is the stately Carson Opera House, which dwarfs the adjacent Excelsior Hotel. The opera house was moved to that location to make room for the new post office. (Jim and Mae Thorpe.)

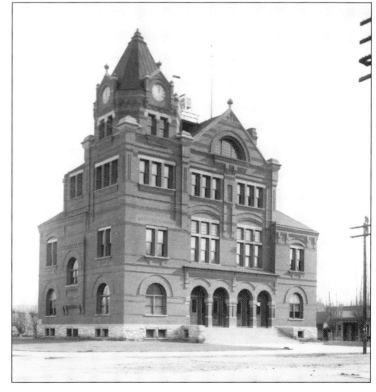

The federal building was completed in 1898, but payment for work was outstanding for many years. In 1900, Theodore Robert Hofer was appointed postmaster by Pres. William McKinley. The *Carson Morning Appeal* reported that, "Well, the plans are now under way . . . to erect in Carson City a magnificent structure . . . with a series of four arcaded doorways, to which there will be a pent roof. . . .and a clock tower." (Pat Cuellar.)

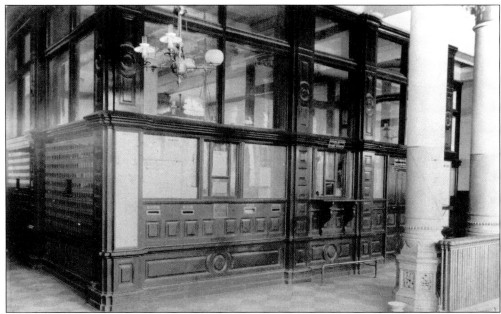

The federal building (and post office) interior is where one's voice could echo from wall to wall. The post office portion of the building was closed in 1971 and used for state offices. The building has since been renovated and renamed the Paul Laxalt Federal Building, and it is home to Nevada tourism. (Bernie Allen.)

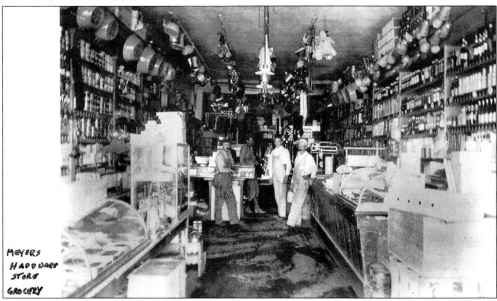

Meyers Hardware, at 101 North Carson Street, was first established by George T. Davis and purchased by George H. Meyers. It was a fireproof building with its own water works and an exterior made from sandstone quarried at the state prison. Meyers supplied stock for farms, ranches, mines, shops, and homes. The *Carson Morning Appeal* published a report called "Business Sketches" by Prof. R. Lewers. George Meyers was a wholesale and retail dealer whose hardware store included "staple and fancy goods, groceries, flour, salt." The building is now the site of the secretary of state annex. (Bernie Allen.)

An advertisement for an event at the Carson Opera House said that the "Electric Wonderland and Moving Picture Company presents the 'Great Fire—Earthquake of San Francisco'." This was one of many programs put on at the opera house whose advertisements were published in the 1906 *Carson Morning Appeal.* (Susan J. Ballew.)

Carson Opera House

J. P. Meder, Manager

One Night Only
TUESDAY EVE., SEPT. 4, 1906

Electric Wonderland and Moving Picture Company

Acknowledged by the press and public to be th ebest ever presented

Great Fire - Earth-quake of San Francisco

First time shown in this city
4000 FEET MOVING PICTURES

Reserved seats75c
General admission25c

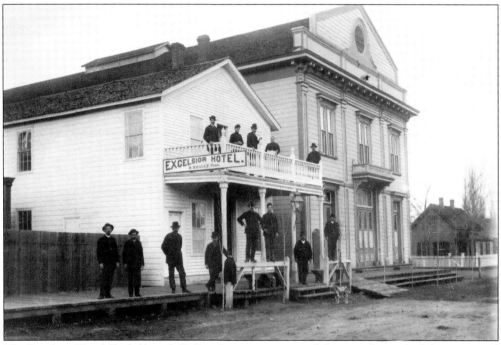

The Excelsior Hotel (far left), with D. Drault as proprietor, and the opera house (right) are pictured around 1920. The opera house featured many musicals and plays each week. In 1886, the Carson Opera House was made more comfortable for the dancing public by placing springs under the foundation piers. It was renovated in 1931, a new furnace was installed, and shortly thereafter, on Sunday, April 5, 1931, it burned to the ground. (Bernie Allen.)

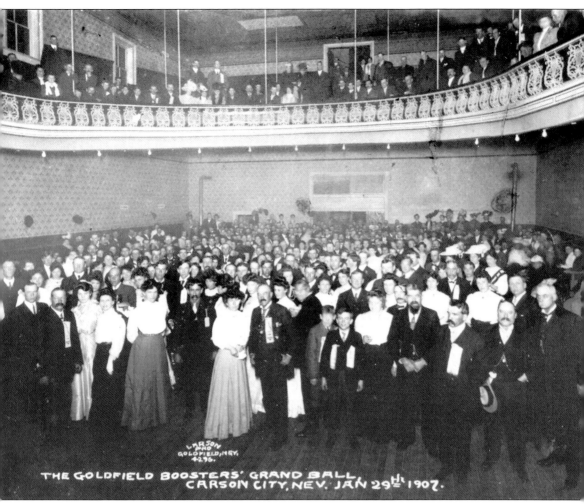

THE GOLDFIELD BOOSTERS' GRAND BALL CARSON CITY, NEV. JAN 29th 1907.

The Goldfield Boosters held their grand ball at the Carson Opera House on January 29, 1907. They appeared before the legislature to ask them to pass a bill moving the county seat from Hawthorne to Goldfield. The January 28, 1907, *Carson Morning Appeal* reported that a special train came from Goldfield to Carson City carrying several hundred people, members of the chamber of commerce and other prominent people. (Bernie Allen.)

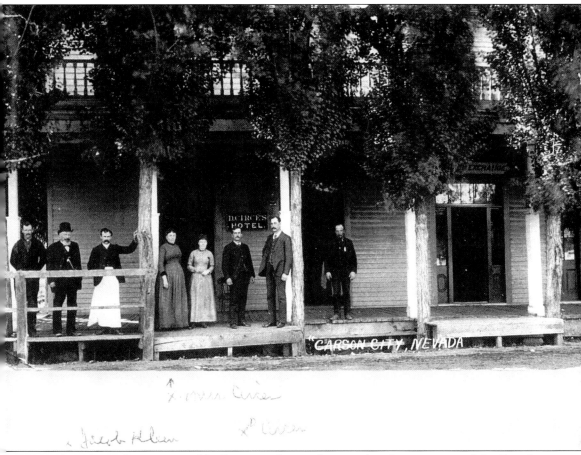

D. Circe's Hotel was operated by Dominic Circe, who was also the proprietor of the French Hotel and the Carson City Exchange Hotel. Jacob Klein, pictured on the left, started the Carson Brewery with John Wagner and August Weyerhauser. In November 1884, the county assessor's annual report listed five first-class accommodations in Carson: the Ormsby House, run by John W. Sharpe; the St. Charles, with proprietor George Tufly; the Arlington, run by W. M. Cary; the Carson Exchange, with proprietor Elijah Walker; and the French Hotel, run by Dominic Circe. Second from left is Jacob Klein, and sixth from left is Dominic Circe. (Southerland Studios.)

MAGNOLIA SALOON
RE-OPENED!

PETER HOPKINS,

Proprietor of this old established and favorite place of resort, takes pleasure in giving notice to his old friends and the Public, that the MAGNOLIA is reopened on the old spot, but in the

NEW SALOON OF THE GREAT BASIN HOTEL BUILDING,

Where, as in former days, can be found the best of

LIQUORS, WINES, CIGARS, &c.

There are also, in the Saloon,

Three New and Splendid Billiard Tables,

With all the new Improvements of Cushions, etc.,

Under the Direction of Mr. HENRY EATON,

The celebrated California Player. TRY THEM!

☞ The Saloon in all its appointments cannot be surpassed by anything of the kind in Nevada Territory

Old friends and the Public are cordially invited to visit the Magnolia.

The Magnolia Saloon was located at the left end of the Great Basin Hotel Building next to the courthouse. (Nevada State Library and Archives.)

The first Carson City courthouse, originally the Great Basin Hotel, was located at the corner of Carson and Musser Streets across the street from the capitol. The rooms were rented for use as a courthouse and jail space. On the left end of the building is the Magnolia Saloon. To the right of the building is Joe Platt's clothing store. It was unusual for a courthouse to have a saloon next door. (Pat Cuellar.)

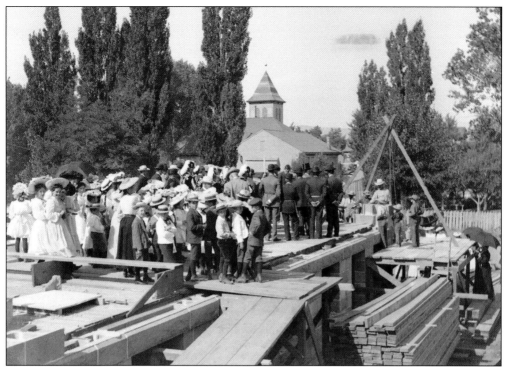

The laying of the cornerstone of the Carson City Public School was in 1904, with the Presbyterian church steeple in the background. The large tripod on the right suspends the cornerstone while the masons conduct the ceremony. The *Appeal* said, "The cornerstone of the new high school will be laid Saturday afternoon, August 8th, with ceremonies conducted by the Masonic Grand Lodge of Nevada with Tracy T. Fair officiating." (Carson City Historical Society.)

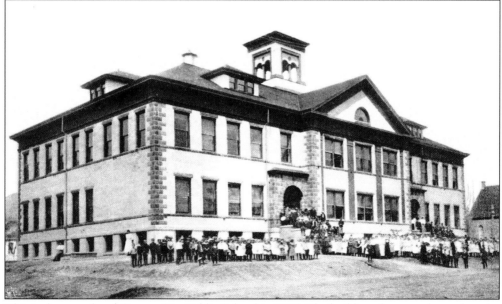

This is the completed Carson City Public School in 1905. The building that once housed grades 1 through 12 is now gone. It stood across the street from the Carson Brewery. (Susan J. Ballew.)

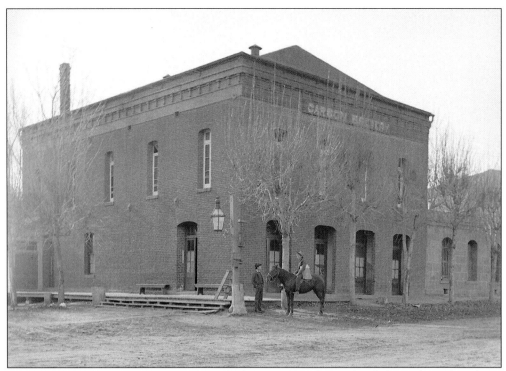

The Carson Brewery on King Street was built in 1860. A horse that belonged to Jake Klein's Brewery preferred beer to water. If left standing near a beer keg, he would turn it over and snuff the stale liquid. Occasionally, he was given good beer and lost no time drinking it. (Pat Cuellar.)

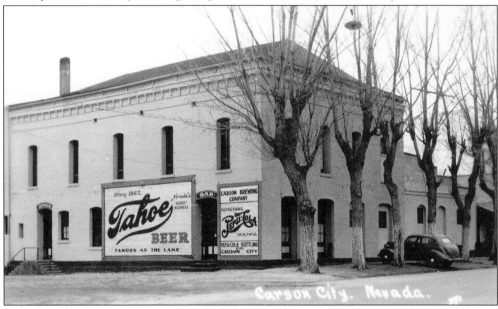

In the 1930s, the Carson Brewery was the home of Tahoe Beer. In 1933, beer was made legal, and the brewery geared up with new equipment. In 1934, the Carson Brewery put Tahoe Beer in cans and short "Steinie" bottles. The building later housed the *Nevada Appeal* and is now the home of the Brewery Arts Center. (Gayle Klette.)

The Ormsby and Nye County Bank, at Proctor and Carson Streets, was Wells Fargo's banking house in 1872. The *Reno Gazette* reported, "The Nye and Ormsby County Bank opened its doors for business today. The interior is handsomely fitted in Spanish mahogany. . . . The officers are T. L. Oddie, president; D. M. Ryan, vice president; George M. Nixon, manager; A. G. Raycraft, cashier; Ross B. Meder, assistant cashier." The structure was demolished and is now the location of the City of Carson offices. (Nevada State Library and Archives.)

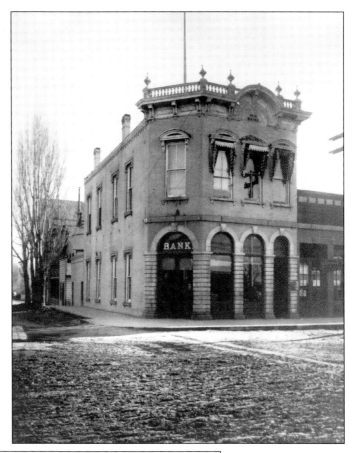

A few years later, the bank was called Carson City Savings Bank and had a capital stock of $100,000. (Nevada State Library and Archives.)

GEO. W. KITZMEYER

Dealer in

Eastern and California

FURNITURE

Carson City, Nev.

All the modern Improvements on

Spring Beds and other Bedding

Constantly on hand.

☞ REPAIRING AND NEW WORK DONE TO ORDER. ☜

PRICES GREATLY REDUCED.

C. W. Kitzmeyer, whose store at Carson and Telegraph Streets was established in 1870, was a dealer in furniture and bedding. He came from Baltimore, Maryland, with his brother, D. G. Kitzmeyer, and opened a saddle and harness business in 1864. The *Carson Morning Appeal* reported, "Mr. Kitzmeyer's ground floor salesroom fronting on Carson Street, is one of the largest in the City." The Kitzmeyer Building stands today and is the third building on the right with a porch. (Above, Nevada State Library and Archives; below, Nevada Historical Society.)

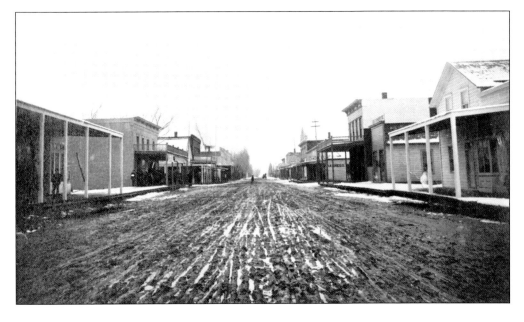

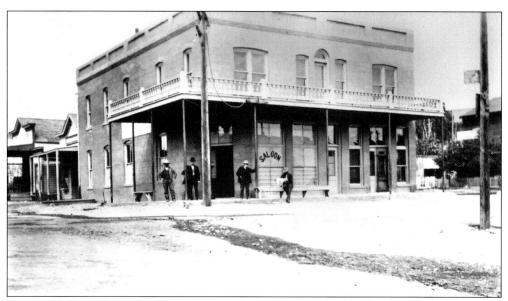

Charles W. Friend's merchandise shop was next door to a saloon at 104 North Carson Street. In 1889, Friend had just received a shipment of watches, and as reported in the *Carson Morning Appeal*, had "the most peculiar timepiece that we ever saw . . . the dial looks like an ordinary light one, but when taken into the dark, it glows." (Nevada State Library and Archives.)

Charles W. Friend was a watchmaker, jeweler, and engraver. He also specialized in mathematical and engineering instruments. (Nevada State Library and Archives.)

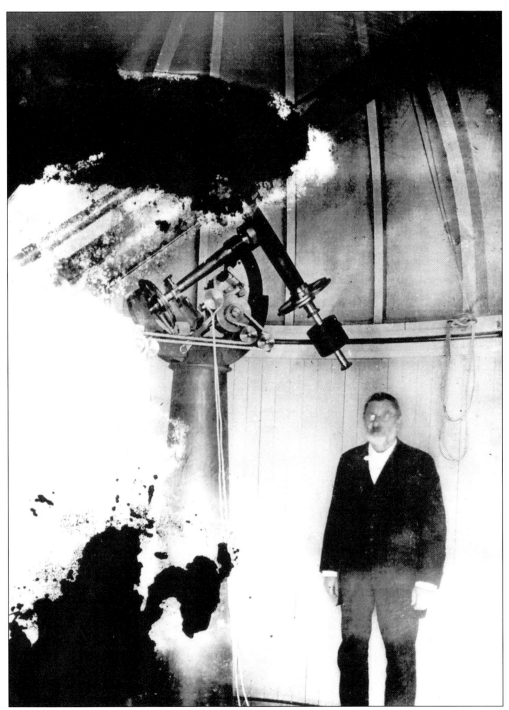

Charles W. Friend stands inside his observatory. Born in 1835, he was a Prussian immigrant who had an observatory located at the corner of Stewart and King Streets. He established Nevada's first weather service in 1887, and weather for the day was signaled by a flag flying at the state capitol. He set up a seismograph in the basement of the capitol building and recorded the 1906 San Francisco earthquake. (Bernie Allen.)

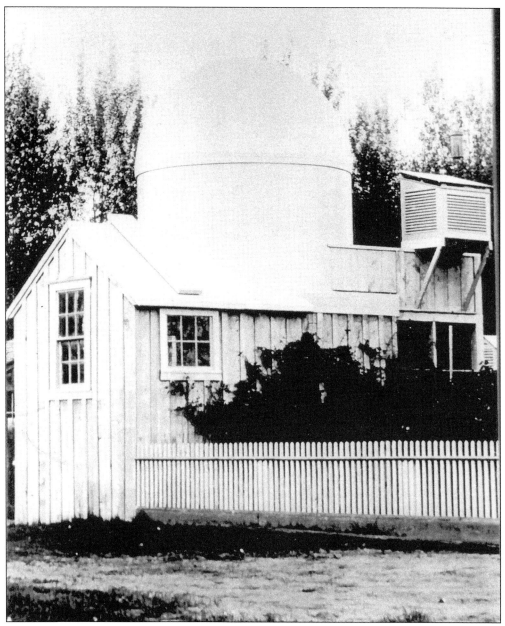

Charles W. Friend's observatory is seen as it stood in 1887. The *Carson Morning Appeal* called Friend "a perambulation timepiece. He not only knows about watches and clocks, but is sort of a local astronomer and can tell all about the stars, the winds and the rains." He built a domed observatory to house a 6-inch reflecting telescope in 1875. His home was at Stewart and King Streets. (Bernie Allen.)

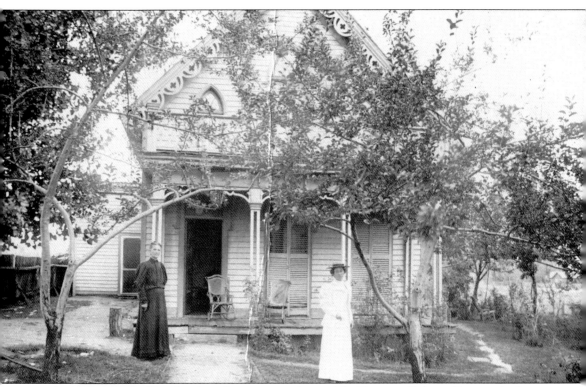

Annie Roberts and her daughter, Josie, pose in front of the Foreman-Roberts House, which was moved from Washoe City to Carson City in 1872 and placed on land with an artesian well. The original lean-to kitchen extends beyond the back of the house. According to Thurman Roberts, the last member of the Roberts family, the house was moved to Carson City on a Virginia and Truckee flatcar. However, no proof, such as bills of lading, has been located. Virginia and Truckee Tunnel No. 1 at Lakeview would have made it difficult to maneuver a house because of the narrow passage. The actual mode of transportation from Washoe City to Carson City remains unresolved. (Carson City Historical Society.)

Josie and Mary Roberts, daughters of James Doan Roberts and Annie Roberts, take time out to picnic with friends in the abandoned Sutro Tunnel east of Carson City in the early 1900s. The Sutro Tunnel was built to drain and ventilate the Comstock mines. The main portion of the tunnel was completed in 1878. (Carson City Historical Society.)

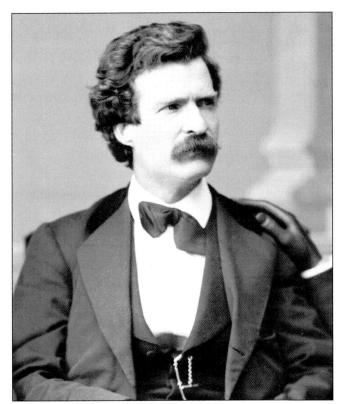

Mark Twain (Samuel Langhorne Clemens) came to Carson City in 1861 at the request of his brother Orion Clemens, who was appointed secretary of Nevada territory by Abraham Lincoln. (Library of Congress.)

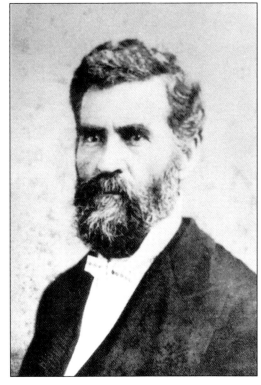

Orion Clemens, Nevada territory's first secretary, came to Carson City with his wife, Molly, and daughter, Jennie. Mark Twain wrote about his travel experiences in *Roughing It*. "My brother had just been appointed Secretary of Nevada Territory— an office of such majesty . . . what I suffered in contemplating his happiness, the pen cannot describe. And so when he offered me . . . the sublime position of private secretary . . . my contentment was complete." (Nevada State Library and Archives.)

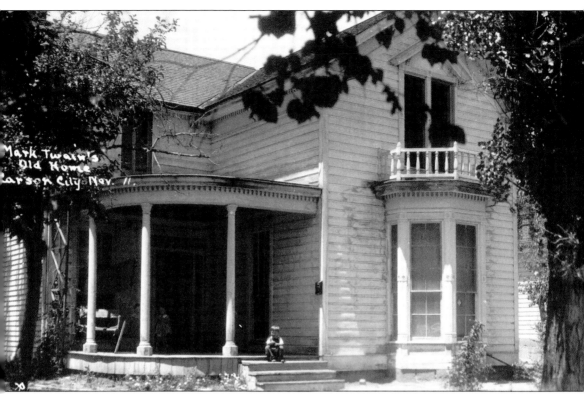

Although this home is called the Mark Twain house, it belonged to his brother Orion Clemens, who came to Nevada territory as its first secretary. Orion had this house built at the corner of Spear and Division Streets at a cost of $12,000 for the house and furnishings. Mark Twain lived in this home with his brother for a few months. (Gayle Klette.)

The Frank Murphy Home, located at 1112 North Carson Street, was built in 1874. The mansard roof was the first of its kind in Carson City. One of its longtime owners, Frank Murphy, was employed by the Virginia and Truckee Railroad for 51 years. The house is still standing today and is the site of Adele's Restaurant. (Bernie Allen.)

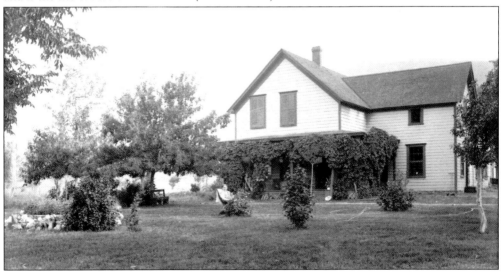

The Larkswood Ranch north of Carson City was the home of Samuel Post and Nellie Mighels Davis. On the lawn is Nellie Davis, owner of the *Carson Morning Appeal*. Sam Davis became editor of the *Morning Appeal* and later state controller. He was a humorist, short story writer, poet, and historian. The home still exists in Carson City. (Southerland Studios.)

An open sleigh passes by
the hay yard of Peterson and
Springmeyer on a wintry day.
They were dealers in hay, grain,
and feed and ran three 12-horse
freight teams from the old
Sacramento Hay Yard in Carson
City to Virginia City. P. H.
Peterson was from Germany,
and C. H. Springmeyer was a
prominent local rancher. (Carson
City Historical Society.)

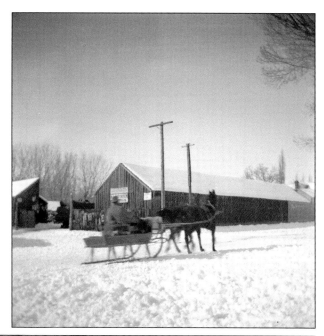

A group of visitors pose at Treadway Park. Treadway Park was established in 1861—Carson City's
first park. It was different from most parks today in that it was privately owned. Aaron Treadway
was characterized in the *Carson Morning Appeal* as a "genial soul and quite a character in his
way." In the background, people relax and enjoy a summer day. The Virginia and Truckee trains
made frequent stops at the park. (Carson City Historical Society.)

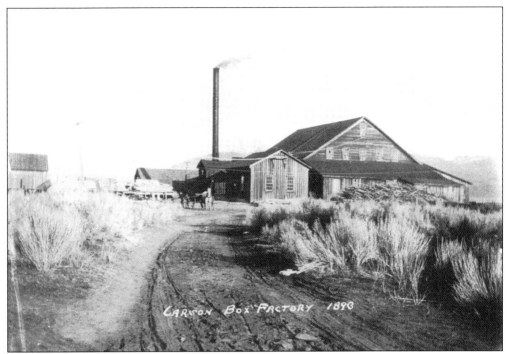

The Carson Box Factory, pictured around 1890, was at the location where Copeland Lumber once stood on South Stewart Street. In 1899, the last work at Carson and Tahoe Lumber ceased when the railroad track to Glenbrook was taken up and the box factory closed. The factory paid out thousands of dollars in wages and affected all avenues of trade in Carson City. (Bernie Allen.)

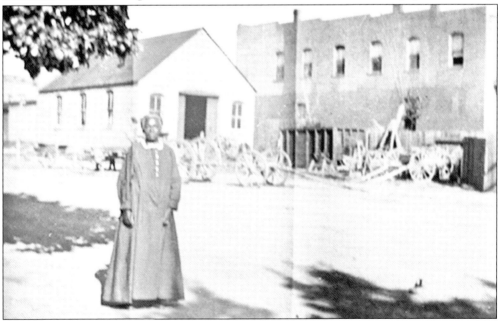

This building being moved in Carson City about 1900 is believed to be at the box factory. The African American woman pictured here was one of the few in Carson City at the time. Note that there are men under the building about to be moved with wagons. (Carson City Historical Society.)

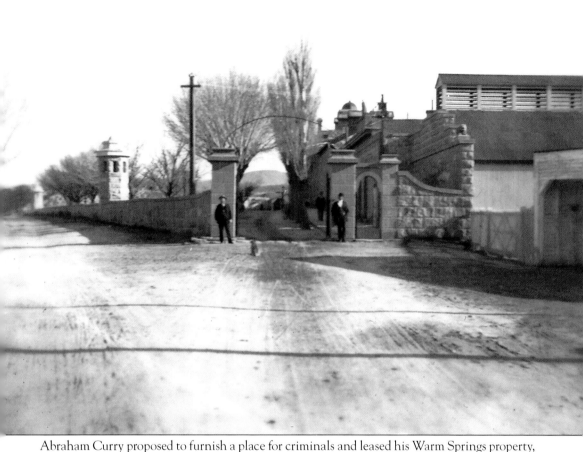

Abraham Curry proposed to furnish a place for criminals and leased his Warm Springs property, which included a stone quarry. That is where the Nevada State Prison had its start. Many of the early buildings of Carson City were made from the stone quarried here by prisoners. Abraham Curry was appointed the first warden in 1861. (Southerland Studios.)

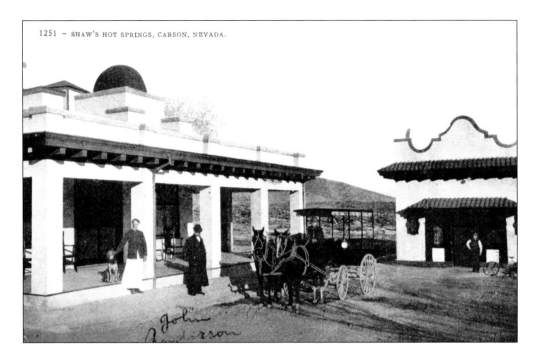

People sought Shaw's Hot Springs as a health resort. The carriage seen pulling into Shaw's is one of many used to carry passengers to the springs, which were a mile northeast of Carson City and today are known as Carson Hot Springs. Shaw introduced a Mission style of architecture and updated "the old swimming tank with its mud bottom" and installed a tank with a concrete floor. (Susan J. Ballew.)

In the July 17, 1880, *Carson Morning Appeal*, Swift's Hot Spring, also known as Shaw's Hot Springs, was reported to be "a resort for the devotee of pleasure and the health seeker." The hot springs were discovered by immigrants to California in 1849, but it was not until 1880 that bathhouses and accommodations were provided and "endorsed by physicians of high repute. . . . Board and room cost $10, $12 and $14 per week." (Nevada State Library and Archives.)

Carson City had a horse racetrack long before gambling was legalized in the state. The track routinely was the site of horse races until it was demolished. It was also the site of the Corbett-Fitzsimmons fight in 1897 and became Camp Sadler in 1898, during the Spanish-American War. (Carson City Historical Society.)

Laura (left) and Deck (right) (last names unknown) pose at the racetrack stadium in Carson City about 1900. (Carson City Historical Society.)

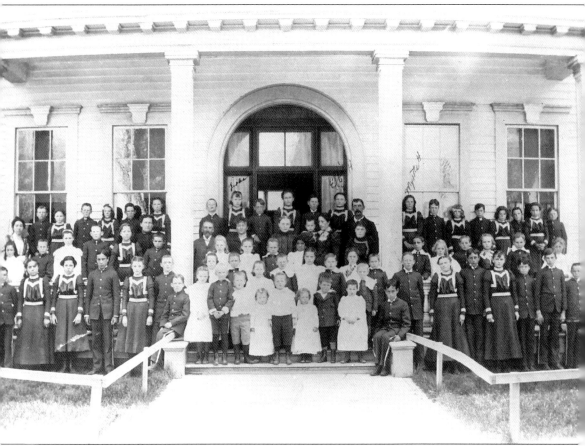

The first Nevada State Orphanage was built in 1873 but burned down in 1902. Children wore uniforms and on Sundays were marched from the orphanage to St. Peter's Episcopal Church for services. The children were schooled on the grounds in a two-room schoolhouse and had their own teachers until the early 1900s, when the children began attending public school. The old school building still stands today and is used as a gym. (Nevada State Library and Archives.)

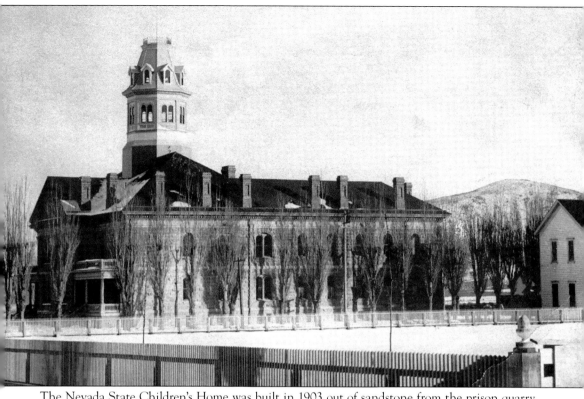

The Nevada State Children's Home was built in 1903 out of sandstone from the prison quarry and featured three stories and a cupola. Girls were housed on one side of the dormitory, boys on the other. The building was demolished in 1963 and replaced with cottages. There was always controversy as to the welfare of the children. In the late 1800s, John Mills was superintendent when this poem was written for the *Carson Morning Appeal*:

I went to the children's home
To see if it was true,
That all the boys and girls therein
Were beat 'til they were blue.
Of course I had to arm myself
Against the coming ills,
Besides you see I had to face
That demon Mr. Mills.
The children in the institute were treated very kind.
The food was good,
the clothes are clean and
we educate the mind.
We teach them how to read and spell
and how to use the pen;
We fit them for the world at large—
it makes them better men.

—E. Starkey (Image courtesy of Bonnie Nishikawa.)

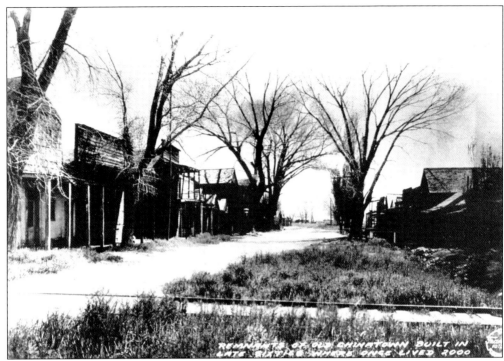

Chinatown was located on the southeastern side of Carson City, in area bounded by Second Street on the north, Fourth Street on the south, Valley Street on the east, and Fall Street (now occupied by state buildings) on the west. Chinatown burned three times, the last time in 1950, and had 789 residents at its peak. A hand-powered waterwheel was used to deliver water from a nearby creek. (Bernie Allen.)

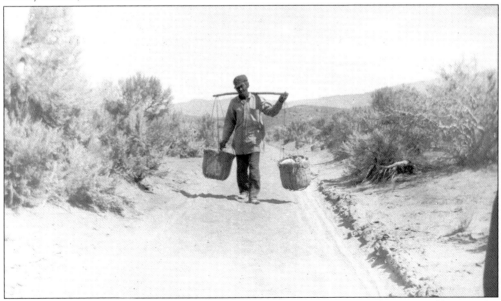

The Chinese of Carson City had wonderful vegetable gardens. The vendor pictured here in the early 1900s may be Gee Hing, a merchant of Chinatown who visited homes with his baskets of vegetables suspended on a pole carried on his shoulders. (Carson City Historical Society.)

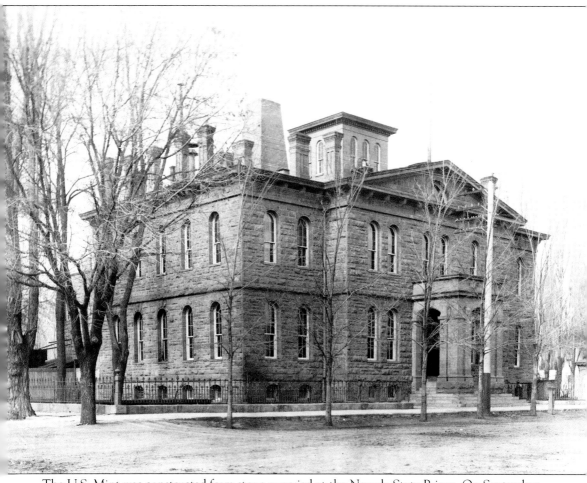

The U.S. Mint was constructed from stone quarried at the Nevada State Prison. On September 24, 1866, when the masons laid the cornerstone, Thompson and West described the occasion as "a fine day, brass band, singing, a big crowd . . . Ceremonies closed by the singing of 'Old Hundred.' " The tracks from the Virginia and Truckee Railroad ran by the north side of the building on Caroline Street. The mint was used to strike coins from Comstock Lode gold and silver. (Pat Cuellar.)

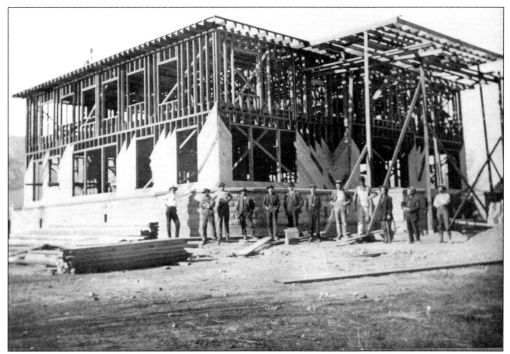

The governor's mansion was constructed in 1908 for $22,700. The *Morning Appeal* reported that T. B. Rickey donated the land as described in the following letter: "I will donate the ground from the north line of Robinson Street to the Yerington barn, which is the width of a full block, less 15 feet which belongs to Mr. E. B. Yerington, and from the west line of Mountain street west, the width of the Yerington block to be used by the City of Carson for the erection thereon of a Governor's Mansion. Very respectfully, (Signed) T. B. RICKEY." Designed by George Ferris, the classical revival style was used. Acting Governor Denver Dickerson was the first governor to live in the mansion. (Above, Bernie Allen; below, Gayle Klette.)

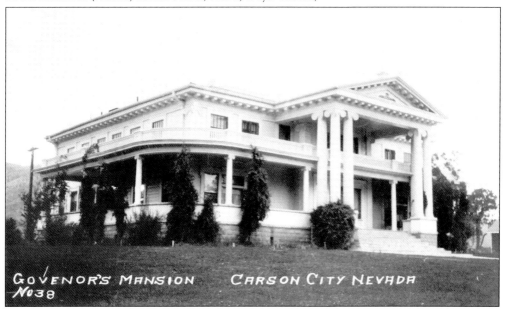

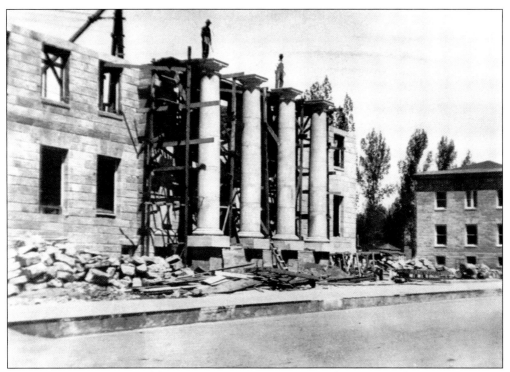

The Heroes Memorial Building was constructed in 1920 and 1921 as a "fitting memorial to Nevada's Soldiers" of World War I. It was designed by Frederic DeLongchamps, who held the position of state architect from 1923 to 1926. The builders are standing on top of the pillars during construction. (Pat Cuellar.)

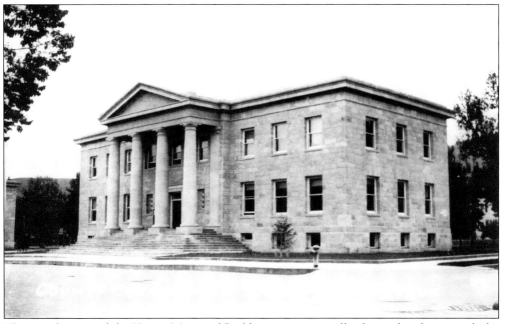

The courthouse and the Heroes Memorial Building were essentially identical in design, with the courthouse being just north of the Memorial Building. (Nevada State Library and Archives.)

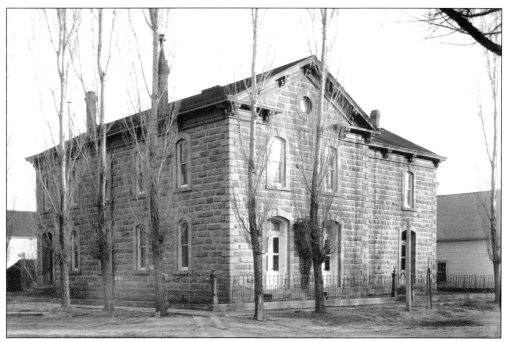

The Nevada State Printing Office was built in 1885 from stone hewn from the prison quarry. Morrill J. Curtis designed the neoclassical structure, which still exists and has been incorporated into the Nevada State Library and Archives building. (Bernie Allen.)

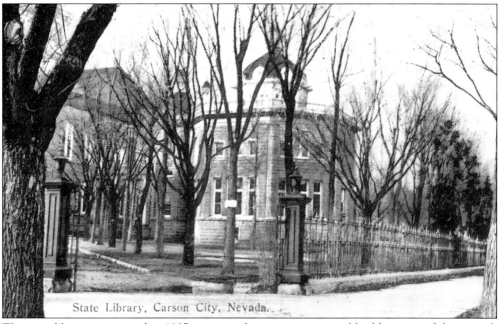

State Library, Carson City, Nevada.

The state library was moved in 1907 to a new three-story octagonal building east of the capitol. Nancy Bordewich Bowers, librarian, said the sky could be seen through the ceiling. The *Morning Appeal* reported on May 16, 1906, "Work on the new State Library building is progressing. . . . The concrete foundation is finished and the first line of stone laid. . . . The stone is cut at the Prison." (Gayle Klette.)

Three

SURROUNDING TOWNS

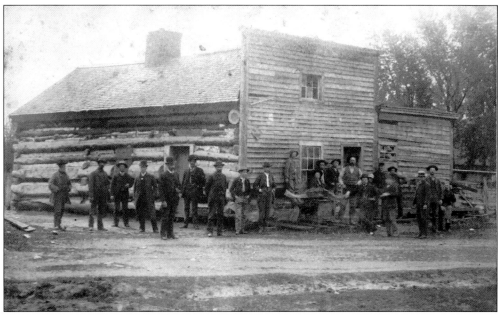

Carson City was not an isolated community but the center of activity. Its existence was built on the communities that existed before it. To the south of Carson City, at the base of the Sierra Nevada, lies Genoa, one of the earliest towns in the area. John Reese built a trading post at Mormon Station in June 1851, and Orson Hyde surveyed Mormon Station in 1856 and named it Genoa. In this early photograph, the men seem to be pleased as they pose in front of one of the first dwellings in Nevada, the old log cabin in Genoa. (Dorothy Dolan.)

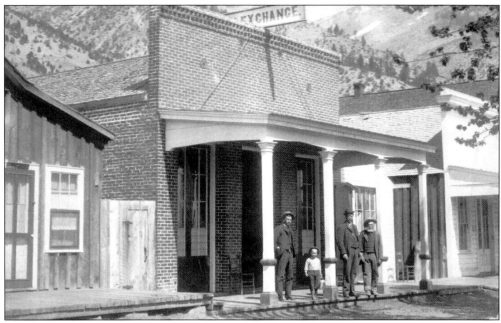

Frank Fettic was owner of Fettic's Exchange, a bar. He came to Genoa in 1883, originally from Hawtry, Canada. The Exchange bar was "headquarters for early day politicians," as reported in the *Nevada State Journal* on July 4, 1948. From left to right are Frank Fettic, Ed Fettic, Jack Raycraft, and Martin Morrison. (Dorothy Dolan.)

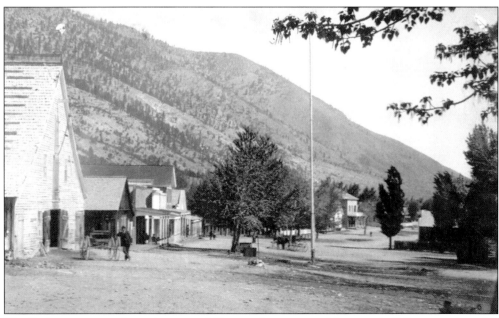

The Exchange was on the main street of Genoa, where many of the same buildings remain today much as they were around 1890. (Dorothy Dolan.)

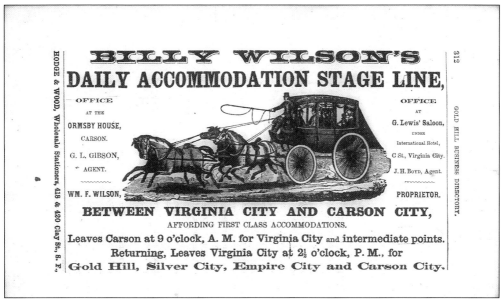

Billy Wilson's Stage traveled the route from the Ormsby House in Carson City to Empire City, Gold Hill, Silver City, and Virginia City. (Nevada State Library and Archives.)

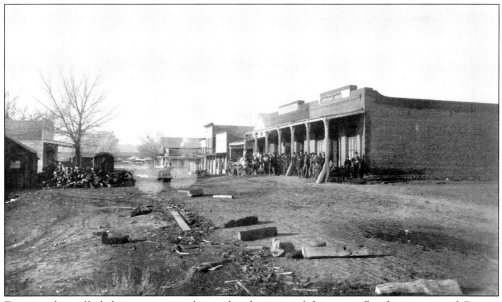

Empire, also called the seaport city by settlers because of the many floods, was east of Carson City near the Carson River. It was established in 1860 to process ore from the Comstock Lode in Virginia City and was the site of many ore reduction mills. According to Thompson and West, "A station called 'Dutch Nicks' was established on the overland road where it touched the river, three and one-half miles from Eagle Ranch. Dutch Nick was Nicholas Ambrose, the first settler in Empire. Later the name was changed to Empire City." Although Empire City no longer exists, there are still remnants of the Mexican Mill, while the mill superintendent's house is still standing and in use today. (Nevada Historical Society.)

Scenes of the mills along the Carson River "within the town [of Empire] are the Mexican and Morgan Mill . . . two miles below is the Brunswick Mill." According to Thompson and West, in 1887 the following mills were still operating along the Carson River: Eureka with 60 stamps, Morgan with 40 stamps, and Mexican, Santiago, Vivian, and Brunswick with 60 stamps, which could be run by either steam or water. (Nevada Historical Society.)

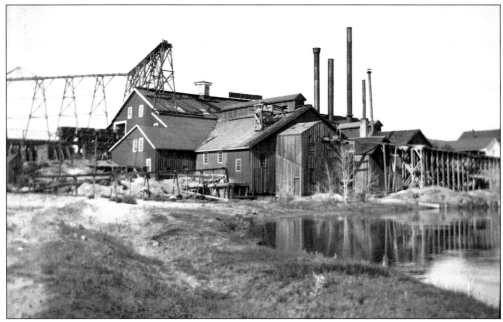

The Mexican Mill was located east of Carson City in Empire. The banks of the Carson River were lined with quartz mills needed for the reduction of ore from the Comstock mines. The Mexican Mill was built in 1860 on the Carson River, close to Empire City. (Carson City Historical Society.)

Gardnerville in the 1900s was a center for the farming community that included Danish, Dutch, and German immigrants. It was also a center for Basque sheepherders. It was founded around 1879, with the Gardnerville Post Office opening on June 28, 1881. (Carson City Historical Society.)

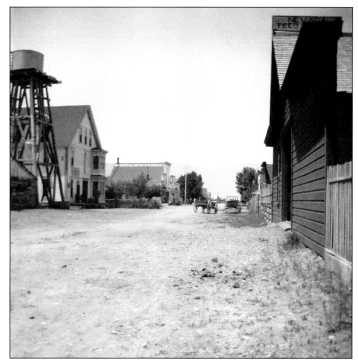

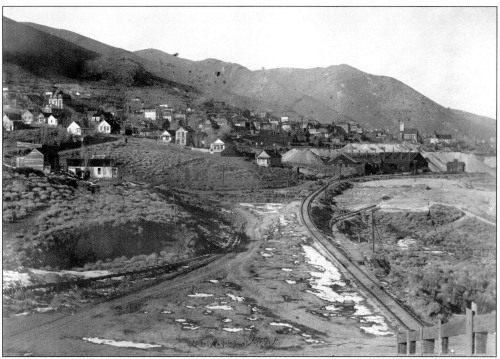

Many of the towns around the state capital had their beginnings early on, the most famous being Virginia City, established in 1859. A panoramic view taken about 1900 looks toward the northwest and includes the four-story Fourth Ward School, which is visible in the far left background. (Pat Cuellar.)

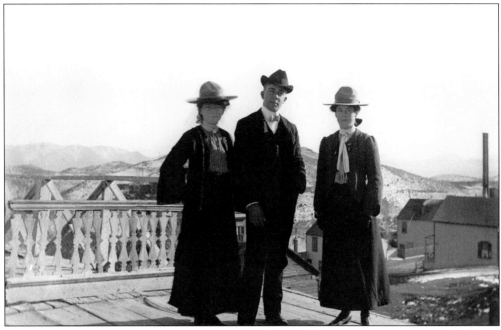

Three Carson City visitors stop to pose on the rooftop of a Virginia City building. (Pat Cuellar.)

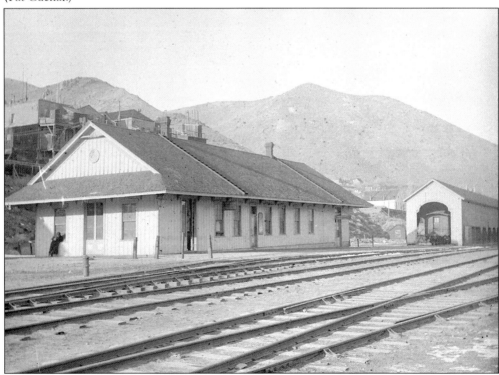

The Virginia and Truckee train depot in Virginia City was located in the center of town. The first portion of the Virginia and Truckee Railroad was completed between Carson City and Virginia City in 1869, and then the line was extended to Reno between 1871 and 1872. (Pat Cuellar.)

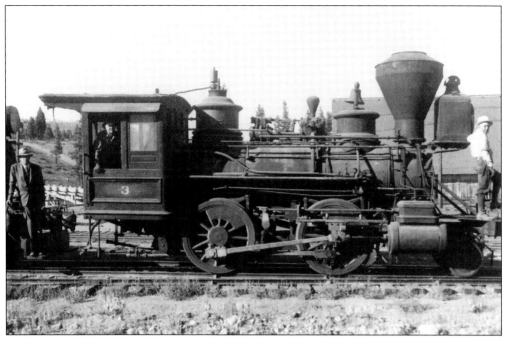

The "Glenbrook" Locomotive No. 1, a Baldwin Mogul, did its work in the mountains near Glenbrook at Lake Tahoe. This narrow-gauge engine was originally part of the Carson and Tahoe Lumber and Fluming Company, established by D. L. Bliss and H. M. Yerington. (Comstock Historic District Commission.)

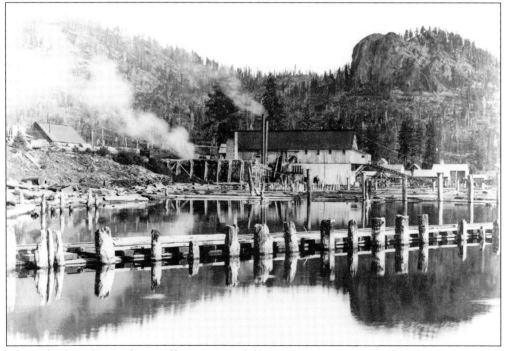

The Glenbrook Lumber mills were in full operation in 1876. (Comstock Historic District Commission.)

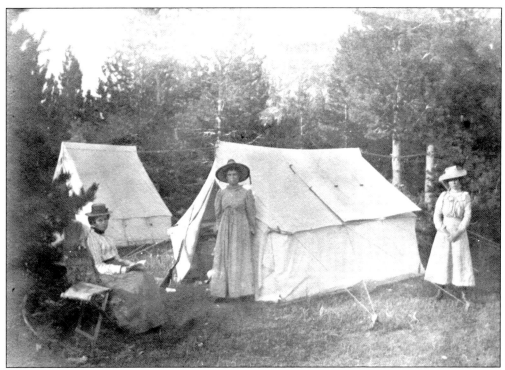

These unidentified ladies are camping at Lake Tahoe. They came prepared with books and rifles. (Carson City Historical Society.)

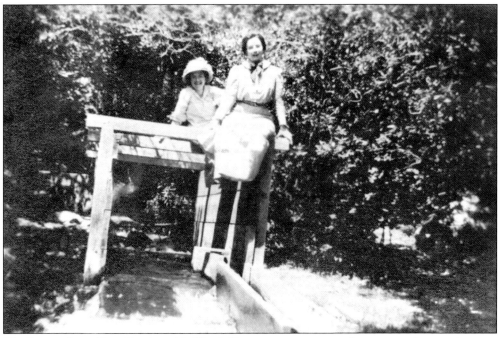

The flumes along Clear Creek and in King's Canyon were a source of mystery and entertainment. These young ladies are including them as part of their recreation in the mountains. (Carson City Historical Society.)

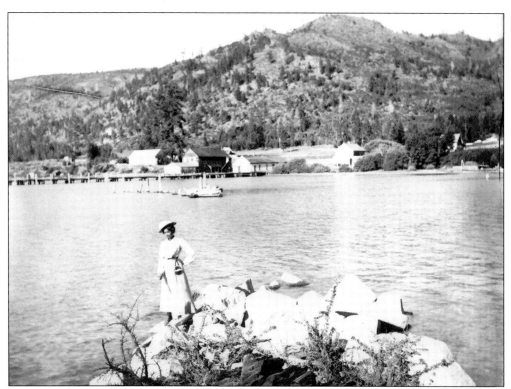

Many Carsonites would take the road up King's Canyon to Glenbrook in the summer months for recreation and relief from the summer heat. (Pat Cuellar.)

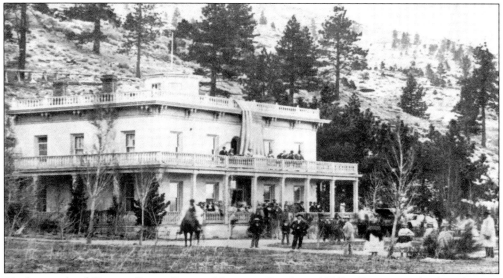

To the north of Carson City is Bowers Mansion. Sandy and Eilley Bowers made their fortune from the Comstock mines. After Sandy Bower's death, Eilley struggled to keep her mansion and turned to her skills as a fortune-teller to make a living. Known as the "Washoe Seeress," she often stayed at the Arlington House in Carson City, where the ladies, according to the *Carson Morning Appeal* in 1895, "learned that Mrs. Bowers knew some very astonishing things. . . . Soon calling on Mrs. Bowers became very fashionable." (Comstock Historic District Commission.)

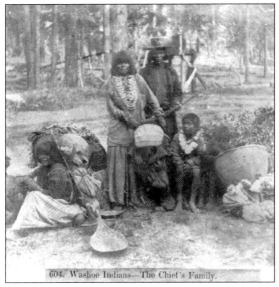

604. Washoe Indians—The Chief's Family.

Carson City's first inhabitants, the Washo (or Washoe; the name is derived from *Wa She Shu*, meaning "the people"), were here for at least 9,000 years and lived in the nearby mountains and valleys. "The boundaries followed the Pine Nut and Virginia Range, to the east. . . . The center and heart of Washo territory included Lake Tahoe and the upper 20 valleys of the Walker, Carson, and Truckee Rivers," according to *A Washoe Tribal History*. The Washo Indians are native to the Carson City area and have a colony inside the greater city limits. Here a group is pictured at Lake Tahoe with a Washo Indian tribal leader. Lake Tahoe was the original summer home of the Washo Tribe. (Both, Library of Congress.)

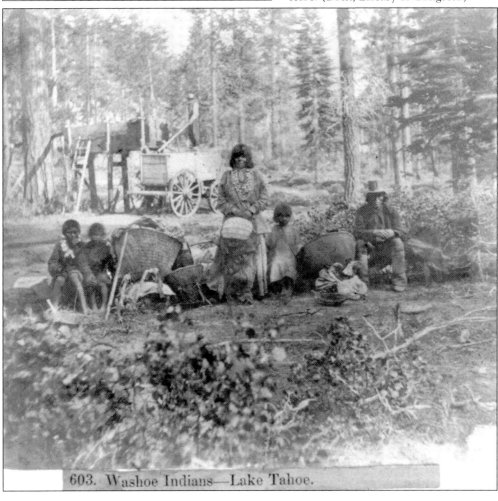

603. Washoe Indians—Lake Tahoe.

Four

TRANSPORTATION

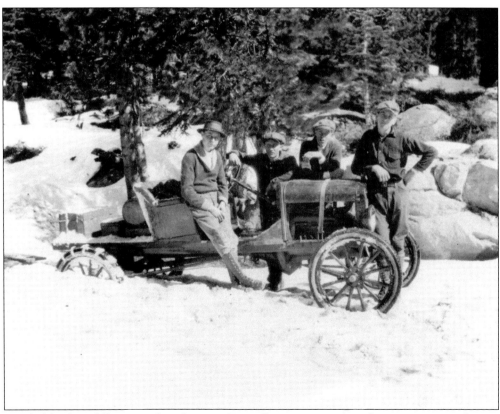

It looks like these folks are stuck in the snow. From all appearances, these four young men are having a great adventure somewhere in the Tahoe Basin in the late 1920s or early 1930s. (Pat Cuellar.)

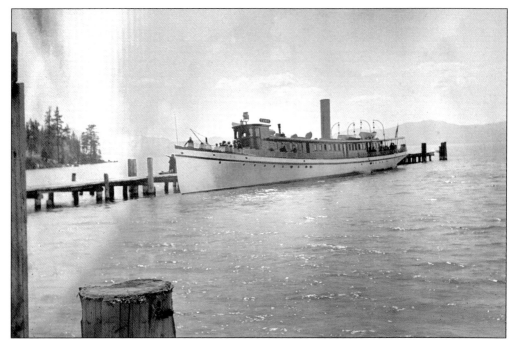

Lumber baron Duane Bliss had the steamer *Tahoe* built in San Francisco in 1894 and transported by train and wagon to Lake Tahoe, reassembled, and launched at Glenbrook on June 24, 1896. The 169-foot steel boat held 200 passengers in comfort. Duane's son, William S. Bliss, after seeing the boat rot from no use, had her scuttled in 400 feet of water off Glenbrook, where she rests today, on August 29, 1940. (Pat Cuellar.)

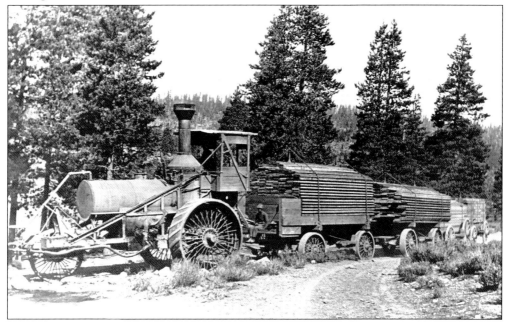

Logging operations continued unabated to provide timber to shore up mines and construct buildings. A steam locomotive tractor pulls wagons of cut timber, presumably coming from Glenbrook to provide building materials to the Tahoe basin. (Pat Cuellar.)

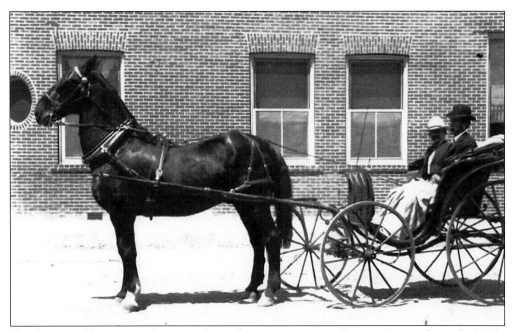

The horse and buggy was the major form of transportation in Carson City in the early 1900s. (Pat Cuellar.)

Friends of the Steinmetz family all wanted to pose for a picture with the new stagecoach. "There ain't no surer way to find out whether you like people or hate them—than to travel with them," according to Mark Twain. (Dorothy Dolan.)

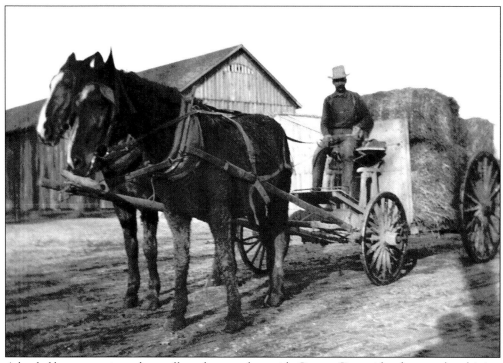

A loaded hay wagon is ready to roll at a hay ranch outside Carson City, with a farm worker driving the team of horses. (Carson City Historical Society.)

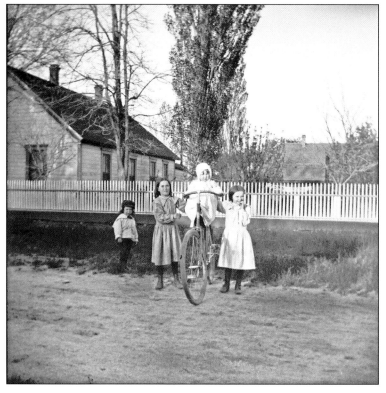

A group of children show off their biking skills in the early 1900s on Carson City's east side at Caroline and Valley Streets in front of a house that is still standing today. The only identified child is Christian A. Smith, on the left. (Carson City Historical Society.)

Five

THE VIRGINIA AND TRUCKEE RAILROAD

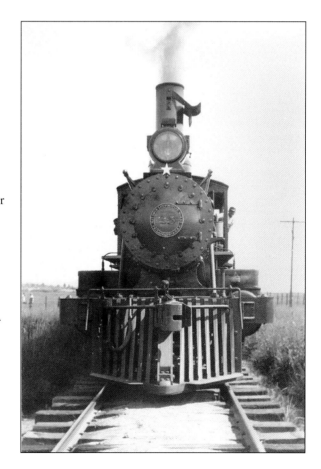

The Virginia and Truckee Railroad arrived in Carson City on September 28, 1869. It was reported in the *Morning Appeal* on that day, "The Steam Horse goes snorting, up and down, past the Mint . . . just as naturally as if it were here when the Washo's first camped in the valley. . . . Must be now that Kingdom's coming." Locomotive No. 25, new in 1905, was sold to RKO Pictures in 1947 and eventually transferred to the Nevada State Museum in 1971. It has a split knuckle coupler and an old link-pin coupler. The smoke splitter is to deflect the blast from the exhaust when passing through tunnels. (Nevada State Railroad Museum.)

VIRGINIA AND TRUCKEE RAILROAD

4 Foot 8½ Gauge,

Connecting at RENO with Trains of the Central Pacific Railroad for

GOLD HILL AND VIRGINIA CITY,

The location of the Great Comstock Silver Mines of Nevada.

This Road is also the shortest and easiest route offered to the traveler from the East for visiting

LAKE TAHOE, THE GEM OF THE SIERRA,

Unequaled in grandeur and picturesqueness, and the sublimity of its natural surroundings.
Altitude, 6,425 feet, 35 miles long, and 15 miles wide.

Stages Leave Carson City Daily at 10 A. M. for Glenbrook Hotel.

Trip from Reno to Carson, across Lake Tahoe, made in one day.

Stages leave Carson every Monday, Wednesday and Friday Mornings for

COLUMBUS, INDEPENDENCE, LONE PINE, AND CERRO GORDO AND PANAMINT MINES.

FARE—From Reno to Carson [31 miles], $2 50; Reno to Gold Hill and Virginia [52 miles], $3 00.

H. M. YERINGTON, General Sup't.

This Virginia and Truckee Railroad advertisement features travel to the Great Comstock Silver Mines as well as to Lake Tahoe, "The Gem of the Sierra." (Nevada State Library and Archives.)

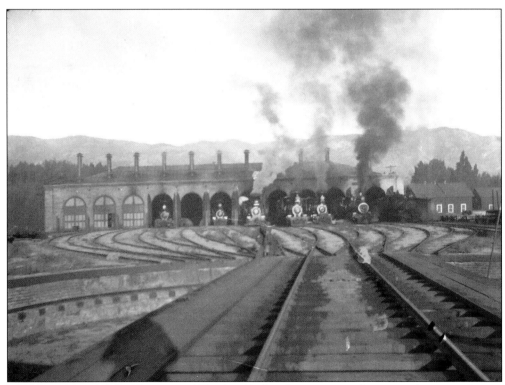

The locomotives of the Virginia and Truckee Railroad steam up at the engine house in Carson City. In his memoirs, A. A. Stafford recalled the Virginia and Truckee of the old days, "when a gandy dancer got a dollar a day, free house rent, coal and coal oil." (Southerland Studios.)

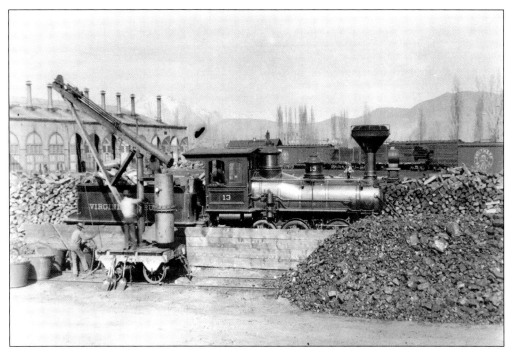

The Virginia and Truckee Railroad's No. 13, *Empire*, is pictured at the fuel pile in Carson City in front of the engine house some time between 1900 and 1910. The hoist was used to lift coal into the locomotive tenders. *Empire* is now at the California State Railroad Museum in Sacramento. (Nevada State Railroad Museum.)

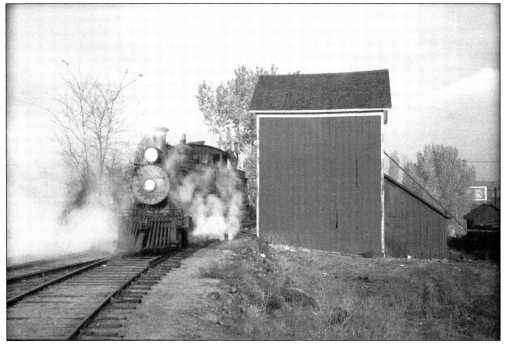

This is Virginia and Truckee Locomotive No. 25 at the Reno water tank. (Nevada State Railroad Museum.)

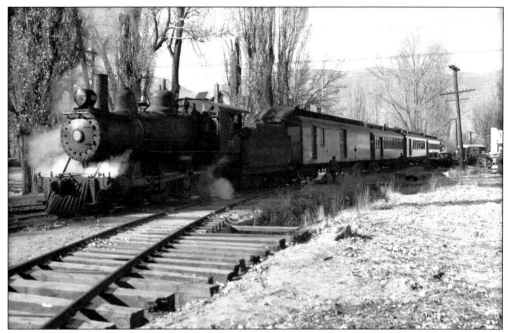

Virginia and Truckee Locomotive No. 27 is pictured without the fake funnel smokestack that was attached in the mid-1940s. In 1955, Sen. Alan Bible granted permission to place the historic Virginia and Truckee No. 27 locomotive, along with a mail car and caboose, on the post office lawn in Carson City in time for the tourist season. The train had been stored at the Virginia and Truckee roundhouse and had once hauled mail from Reno, Virginia City, and Minden to Carson City. (Nevada State Railroad Museum.)

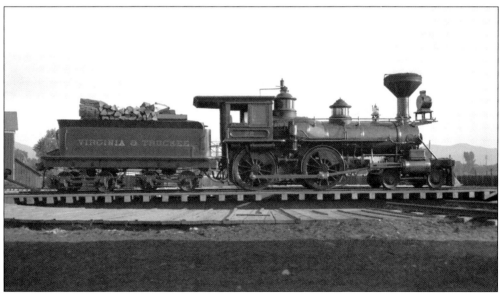

The American Standard No. 22, *Inyo*, was built in 1875 at the Baldwin works in Philadelphia. In 1955, the engine was fitted with a sunflower stack. The locomotive was sold to Paramount Studios and later purchased by the State of Nevada in 1974. It is presently at the Nevada State Railroad Museum in Carson City. (Nevada State Railroad Museum.)

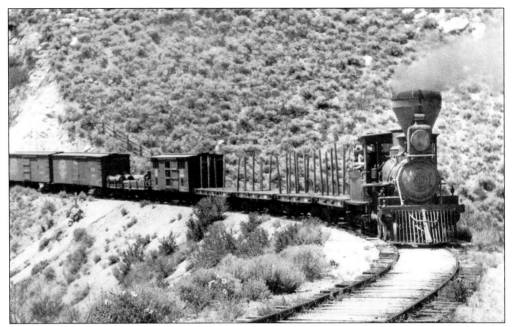

The Virginia and Truckee No. 18, *Dayton*, steams down Lakeview Hill towards Carson City in 1890. (Nevada State Railroad Museum.)

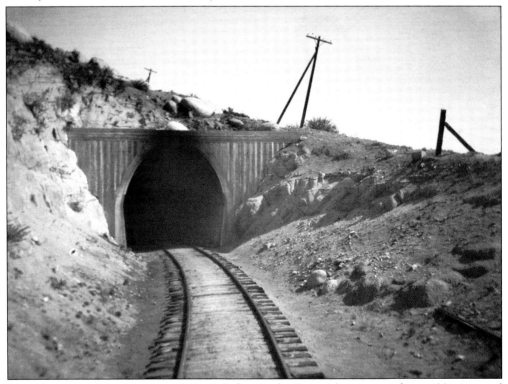

The Virginia and Truckee Tunnel No. 1, Lakeview (or Summit), was one of seven Virginia and Truckee tunnels. Once the train from Reno came through this tunnel, the passengers could see Carson City. (Nevada State Railroad Museum.)

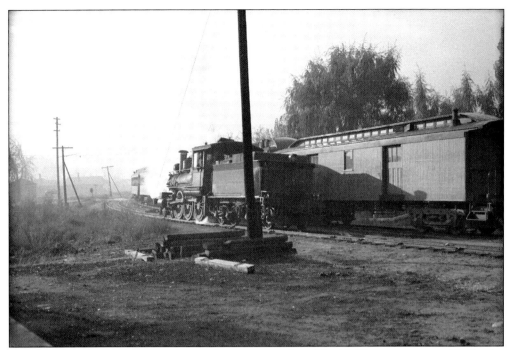

The Virginia and Truckee No. 25 passes by express mail car No. 13. The engine was a 10-wheeler that arrived in 1903 and after many years of faithful service was eventually sold to the Nevada State Museum in 1971, where it was restored in 1980. (Nevada State Railroad Museum.)

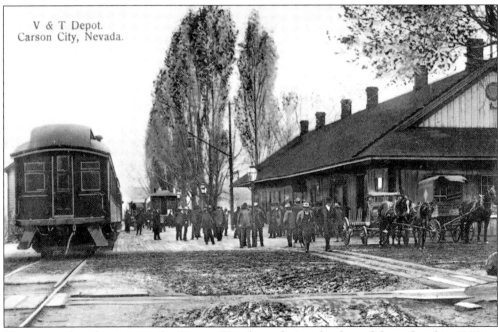

V & T Depot.
Carson City, Nevada.

There was a lot of activity at the Carson City depot during the days of the railroad in 1900, as shown by this scene as the train pulls out and people and horse-drawn carriages wait for the next train to arrive. (Nevada State Railroad Museum.)

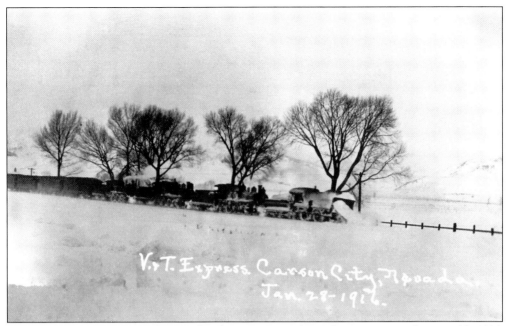

Multiple locomotives plow the way for the Virginia and Truckee express on January 28, 1916. (Southerland Studios.)

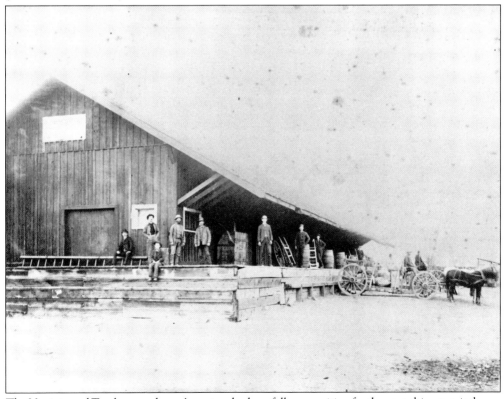

The Virginia and Truckee warehouse's west end, where folks are waiting for the next shipment, is shown here. The warehouse was located near East Robinson and Stewart Streets. (Dorothy Dolan.)

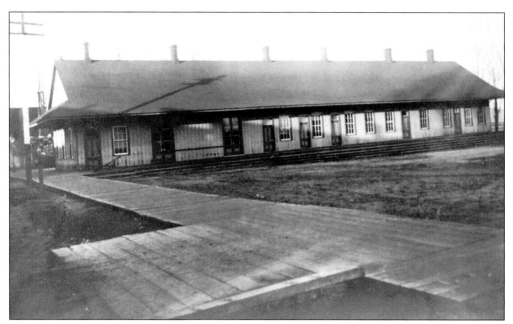

This is a photograph of the Virginia and Truckee Railroad depot in Carson City, as viewed from the south side. When passengers left the depot, they faced the challenge of unpaved and often muddy streets. There was one solution to the problem—boardwalks. (Nevada State Library and Archives.)

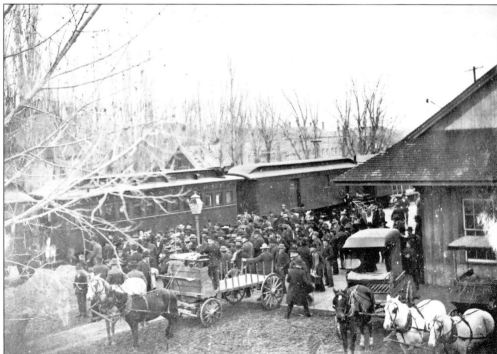

The Virginia and Truckee Railroad depot is pictured in its heyday. Passengers are being picked up and dropped off. The V&T passenger car is in the foreground, while the engine roundhouse is in the background. (Bernie Allen.)

Six

MILITARY

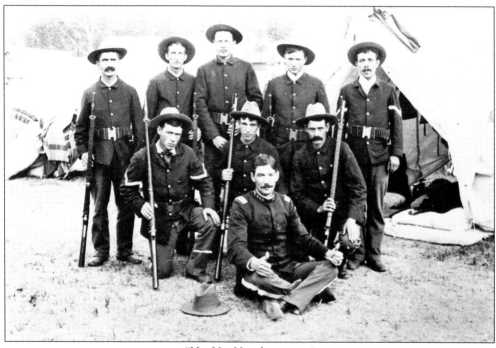

"Ha, Ha, Ha who are we?
First Nevada Cavalry, Sagebrush boys, don't you know
Now to Frisco we will go

— Cpl. Andrew Wammack, *Daily Independent*

Camp Sadler, named for Gov. Reinhold Sadler, was established during the Spanish-American War at the racetrack in Carson City. To make the area ready for the racing season, the camp was moved to Treadway's Field, now known as Treadway Park, on the west side of Carson City. It was named Camp Clark. (Dorothy Dolan.)

ARBORS.

LOGHOUSE SPRING.

TREADWAY'S PARK
RANCH AND RESIDENCE OF A.D. TREADWAY,

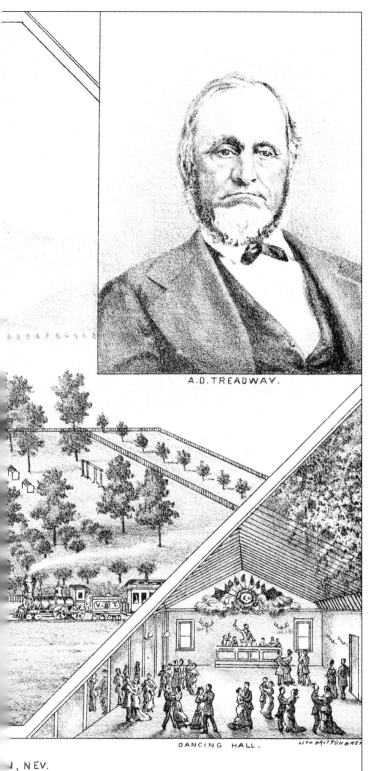

A.D. TREADWAY.

DANCING HALL.

LITH. BRITTON & KEY

I, NEV.

Treadway Park was a military encampment in 1898. Most of the infantry troops mustered for the short war spent the summer waiting for orders, with many becoming frustrated as the Spanish-American War neared an end. Some ended the war locked up in Treadway's milk house for fighting. Others passed the time playing poker with matchsticks. Some 40 men remained in Carson City to put away the camp, and some finished their stay at the encampment brawling and drinking. By October 1898, a cold snap forced many men that had wandered away back to Carson for furloughs, but they ended up going door-to-door claiming hunger and distress. Congressman Francis G. Newlands, Sen. William M. Stewart, and *Appeal* editor Sam Davis interceded on their behalf. As a result, overcoats were issued from the armory and accommodations were made at local hotels. (Nevada State Library and Archives.)

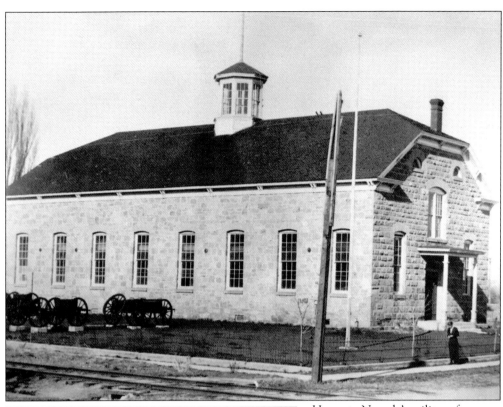

Home to Nevada's military for almost three quarters of a century, the Carson Armory stands today as a maintenance building for the State of Nevada's Buildings and Grounds. (Bernie Allen.)

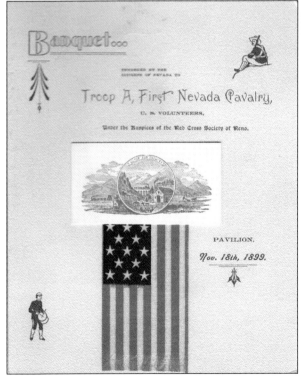

Nevada was proud of Troop A, 1st Nevada Cavalry. The Red Cross Society of Reno put on a huge banquet on their behalf at the pavilion on November 18, 1899. During the Spanish-American War of 1898, the *Appeal* wrote: "There is something irresistible about a soldier to a woman. . . . A woman admires brawn and bravery and a man with a four-inch chest expansion; a man that has passed under the critical eye of the examiner. . . . Besides this he is getting ready to go forth and defend the flag and risk his life to be a hero." (Leisure Hour Club.)

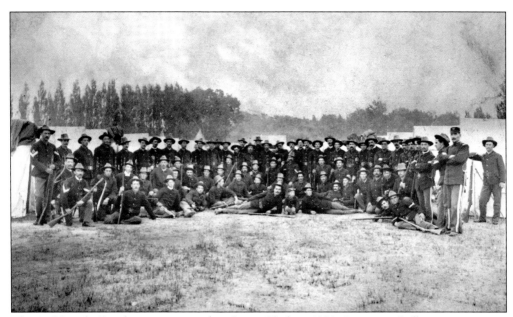

The 1st Nevada Cavalry was stationed at Camp Clark in 1898. Governor Sadler sent a message to Secretary of War Russell Alger following the attack on the battleship *Maine*: "Can furnish 85 men for mounted rifle service in ten days. Nevada most urgently requests . . . infantry battalion of four or six companies of 60 or 75 men each, equipment for 300 men now, 85 tents, 10 officer's wall tents . . . Nevada National Guard second to none as riflemen." (Dorothy Dolan.)

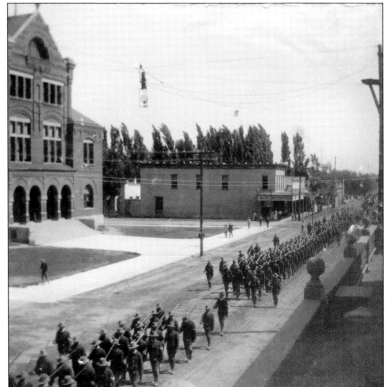

Soldiers in front of the federal building are marching to war. This view is of the 1st Nevada Cavalry marching to Camp Clark in preparation to being shipped overseas. Carson City garrisoned many armies over the years; this one existed for a short period in 1898 during the Spanish-American War. Camp Clark was west of the state capitol. (Reno Consolidated Coin.)

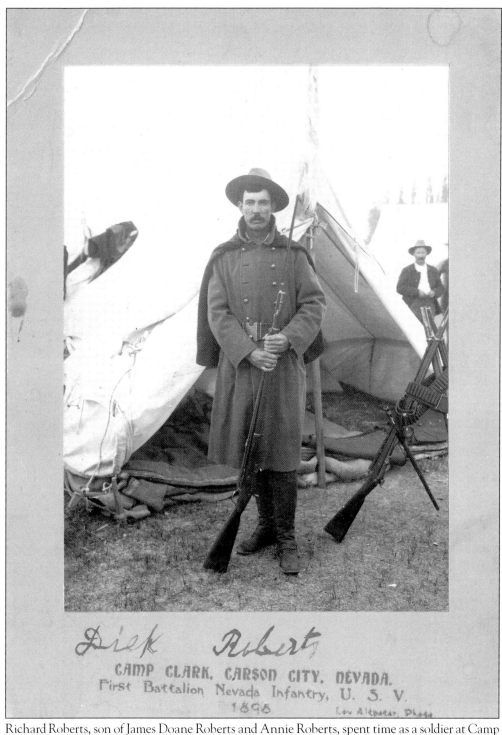

Diek Roberts

CAMP CLARK, CARSON CITY, NEVADA.
First Battalion Nevada Infantry, U. S. V.
1898
Lev Altpeter, Photo

Richard Roberts, son of James Doane Roberts and Annie Roberts, spent time as a soldier at Camp Clark in western Carson City. (Carson City Historical Society.)

Seven

PRES. THEODORE ROOSEVELT

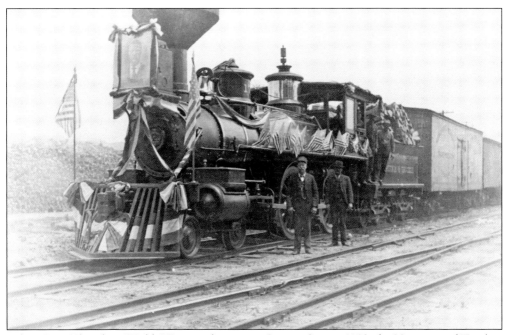

When Pres. Theodore "Teddy" Roosevelt came to Carson City in 1903, the Virginia and Truckee Railroad's No. 17, *Columbus,* was decorated with bunting, flags, and a portrait of the president mounted on the headlight. When he stepped from the train, Roosevelt was greeted by several thousand people, and by the time he got to the capitol grounds, the *Carson City News* on May 19, 1903, reported an "estimated seven thousand people listened to the finest address ever made." (Nevada State Railroad Museum.)

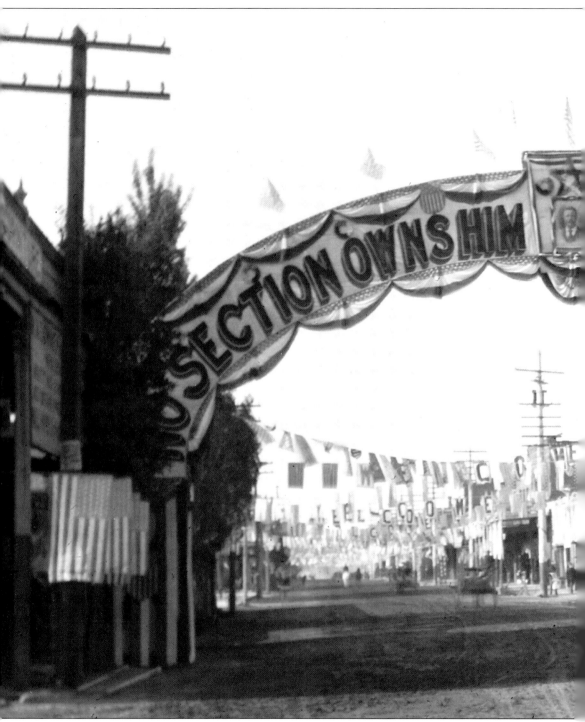

It was called a Day of Days when Theodore "Teddy" Roosevelt, the 26th president of the United States, visited the capital city on May 19, 1903. Roosevelt, at age 42, became the youngest person to become president, having succeeded Pres. William McKinley after his assassination in 1901 by anarchist Leon Czolgosz. A progressive and a Republican, he was the first president to call

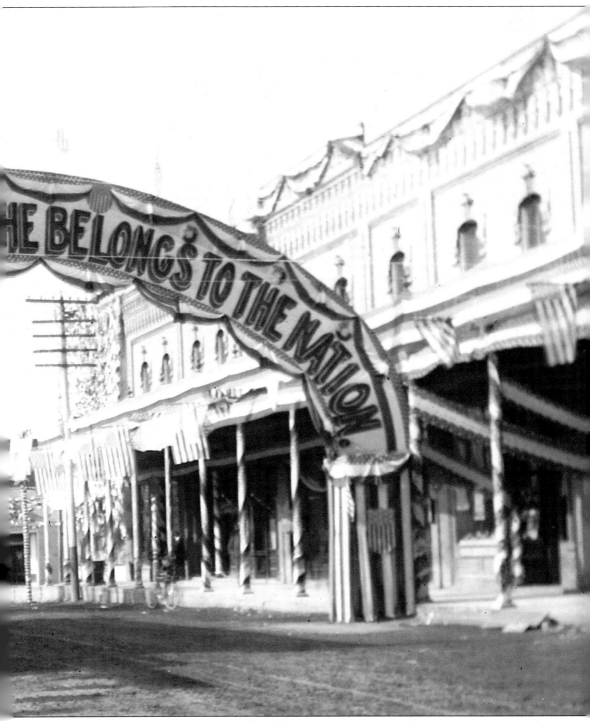

for universal health care and national health insurance. As an outdoorsman, he promoted conservation. As reported by the *Carson City News* on May 19, 1903, the Arlington Hotel displayed a triumphal arch bearing the words "No Section Owns Him. . . . He Belongs to the Nation." (Pat Cuellar.)

A reception committee was assigned to make sure that all was right and Carson City would not be outdone. An arch was constructed across Carson Street near the mint, and orators practiced their presentations. (Pat Cuellar.)

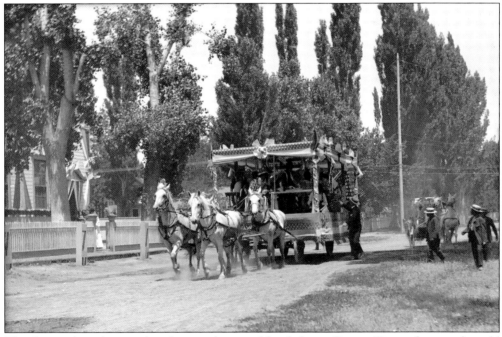

The *Carson Appeal* wrote that the president would only be in Carson City an hour and would arrive by train at the station. A special carriage was prepared, and side streets from the station to the capitol were roped to prevent teams from crossing the procession. People from around the state were to be in Carson to see and hear the president. It was to be a grand day. (Pat Cuellar.)

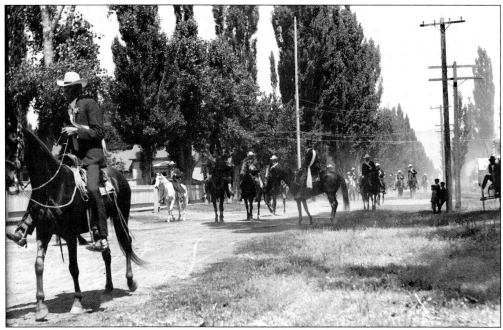

"The visit of the President has more weight to it than most people realize," H. R. Mighels said in the *Carson Morning Appeal*, "The President, while not born in the West, has adopted western modes that have put us more in touch with the west and her needs than any President. . . . He will assist on the adoption of irrigation measures that will be of a general benefit to the whole people." (Pat Cuellar.)

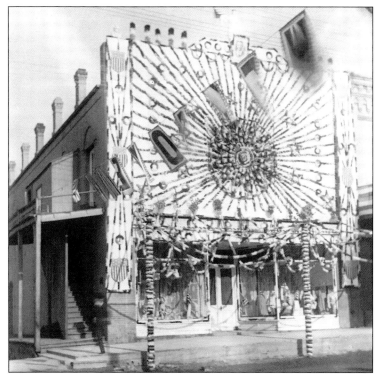

Three to five streamers of flags crisscrossed the street. "Each of these streamers averaged fourteen flags," according to the *Carson City News*, and Gray, Reid, Wright, and Company was decorated with ribbons, with a picture of Roosevelt on top of the building. (Pat Cuellar.)

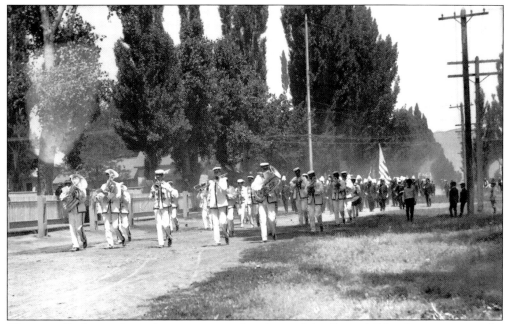

The specially designed parade carriage passed in front of the Central School on its way to the capitol grounds in Carson City, with marchers leading the way. (Both, Pat Cuellar.)

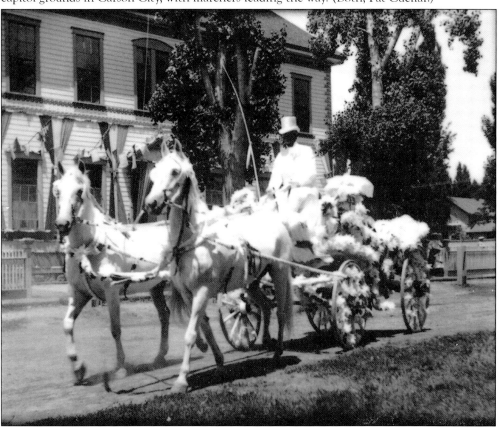

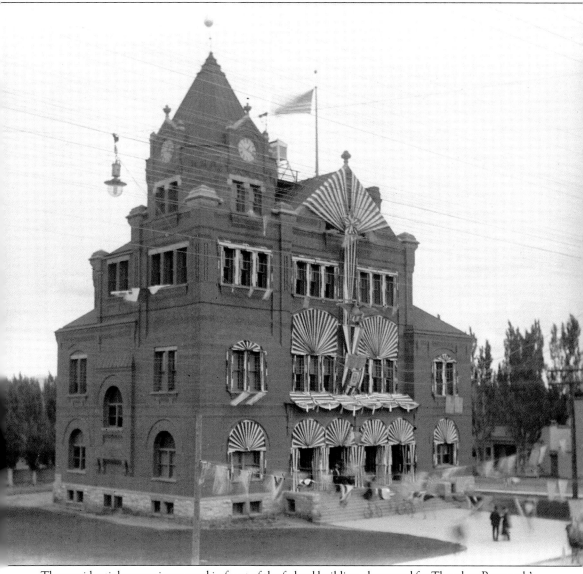

The presidential procession passed in front of the federal building, decorated for Theodore Roosevelt's visit to Carson City in 1903. The federal building was "never before so handsome . . . trimmed in most elaborate design, the portrait of President Roosevelt being surmounted by the National eagle and one gigantic star," according to the *Carson City News* on May 19, 1903. (Pat Cuellar.)

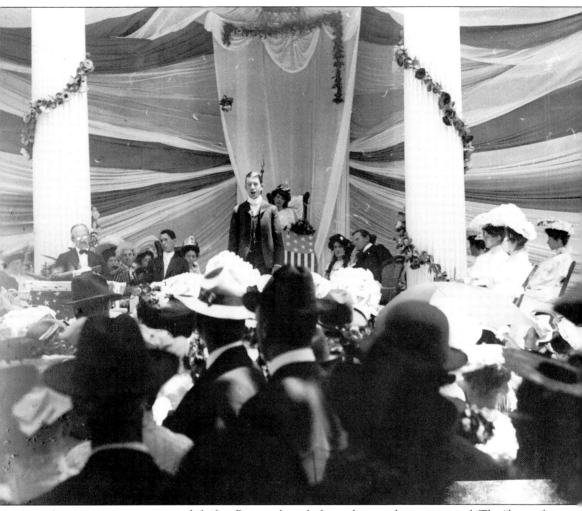

An announcement was made before Roosevelt took the podium at the state capitol. The "hero of San Juan" was surrounded by a display of rifles and a pair of buffalo heads. As the *Carson Morning Appeal* reported, "The President was seated in a chair made of elk horns, and stood upon a robe made from the hide of a musk ox." For his soundness of purpose and business-like approach, Teddy Roosevelt won the hearts and minds of Nevadans. (Pat Cuellar.)

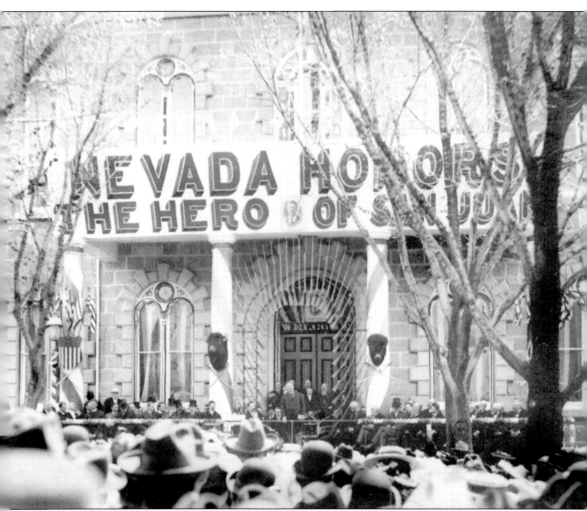

Teddy Roosevelt appeared on the capitol steps. He began his speech by saying "Mr. Governor, Mr. Mayor, and you, my fellow-citizens: It has been a great pleasure to be introduced in the more than kind words the Governor has used, because the Governor has been a genuine pioneer. Here in this great western country, the country which is what it is purely because the pioneers who came here had iron in their veins, because they were able to conquer plain and mountain, and to make the wilderness blossom, we are not to be excused if we do not see to it that the generation that comes after us is trained to have the sum of the fundamental qualities which enabled their fathers to succeed." When Roosevelt ended his speech and was about to depart from Carson, he waved his hat and said: "I hope I will see you all again," according to the *Carson City News* on May 19, 1903. (Nevada Historical Society.)

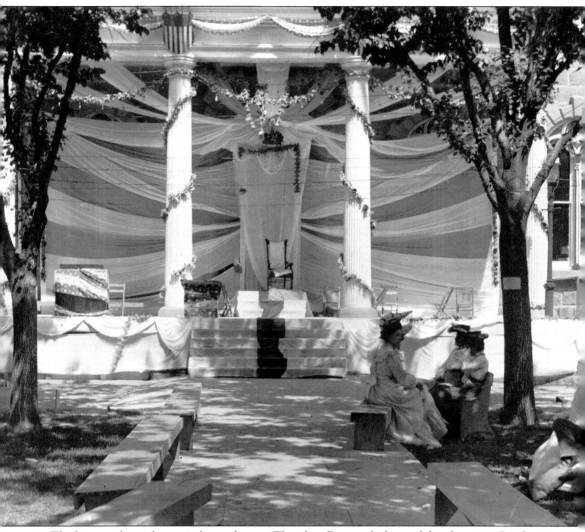

The banner above the capitol steps honors Theodore Roosevelt, hero of the charge up San Juan Hill, Cuba, during the Spanish-American War of 1898. After the event, Carsonites reviewed the happenings of the day. "His visit was not only a good thing for this one city, but for the entire State, as the words carry sound business sense and tingle with Americanism," wrote Harry Mighels, editor of the *Appeal*. According to the *Carson Morning Appeal*, "During his brief visit, [the] President made one friend who will never forget him—the ladies. Especially the matron of the home—she was made to feel that she is the power of the Nation." (Pat Cuellar.)

Eight

THE PEOPLE

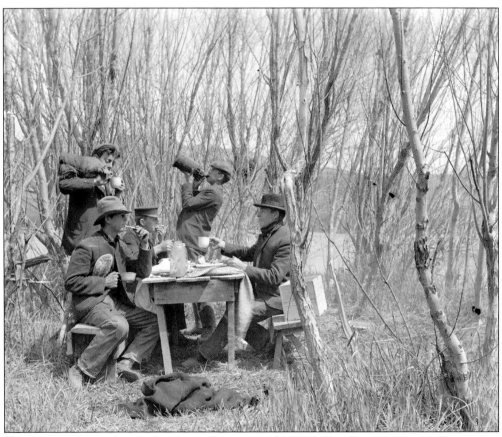

Young men celebrate beside the Carson River around 1900. J. Ross Browne came to Carson City in 1860. He wrote: "I was rather agreeably surprised at the civilized aspect of Carson City. . . . It is really quite a pretty and thrifty little town. Hotels and stores were in progress, but especially drinking and gambling saloons." (Pat Cuellar.)

A gentleman strikes a leisurely pose in Carson City in the early 1900s. Cohn's store is in the background. (Pat Cuellar.)

When Teddy Roosevelt came to Carson City in 1903, the whole town was decorated. The people in town dressed in their finest, including this young lady, who poses in her garden. (Carson City Historical Society.)

Paul Glanzman holds the reins of his new colt somewhere in Carson City in the early 1900s. The boy next to him is probably his younger brother, August. (Carson City Historical Society.)

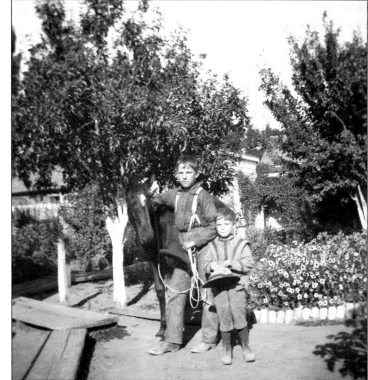

Posing beside her bicycle is Etta Lynch. The state capitol dome is in the background. In 1900, there were 13 African Americans in Carson City. (Carson City Historical Society.)

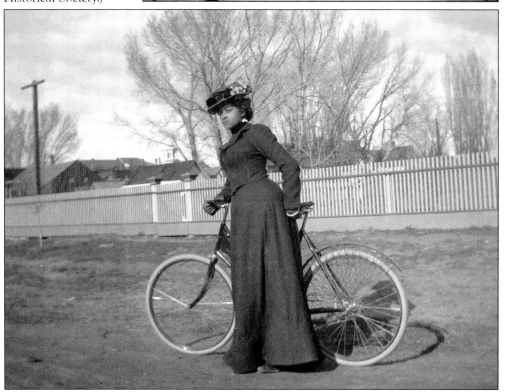

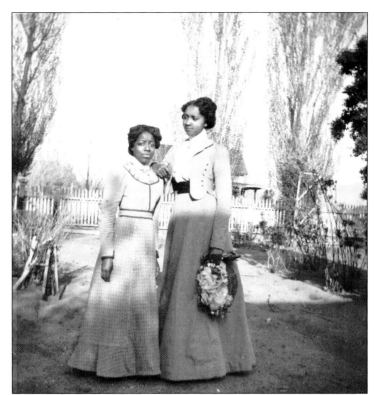

Two young ladies, Suzie (left) and Etta Lynch, get ready for the Roosevelt festivities, while their brother, Charles, takes their picture. (Carson City Historical Society.)

There were many small ranches surrounding Carson City. L. Vaughn enjoys a sunny afternoon riding horseback sidesaddle. (Carson City Historical Society.)

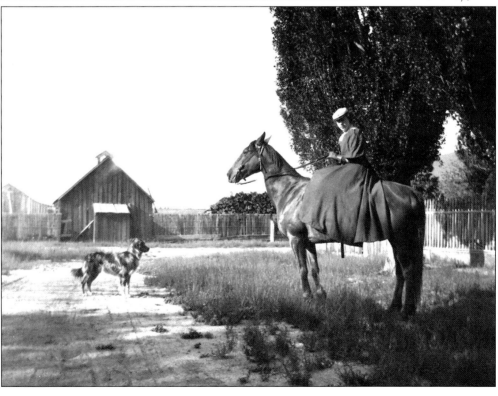

Clara Crisler, daughter of Sheriff "Silver Bill" Crisler, grew up to become a noted historian and also created the second Nevada state flag, which was flown on the battleship USS *Nevada*. Her house at Caroline and Minnesota Streets is still standing. (Carson City Historical Society.)

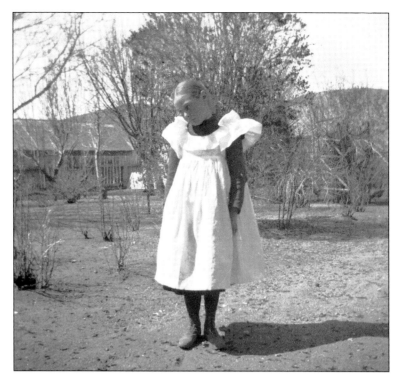

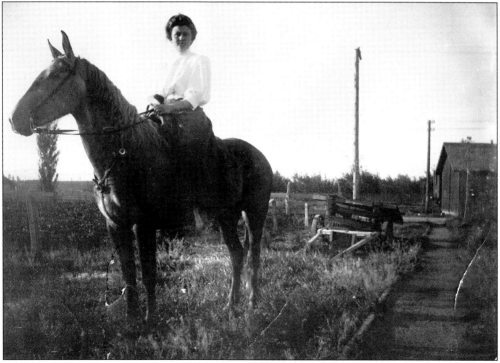

Ruth Steinmetz is practicing her riding skills. Her father operated the F. J. Steinmetz Drug Store and sold stationery, Kodak cameras, and photographic supplies. The store was opposite the Carson City Post Office. (Dorothy Dolan.)

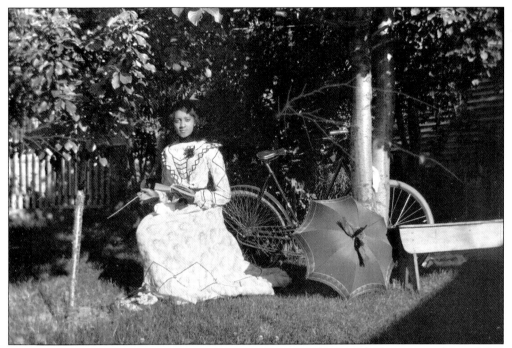

A young lady poses in the garden while reading her book. She is ready for a sunny day with her opened parasol, while the bicycle in the background provides a practical means of transportation. (Carson City Historical Society.)

It was probably a cool winter day when Wil Decker and his carriage stopped at the Brougher house's back porch in Carson City. (Carson City Historical Society.)

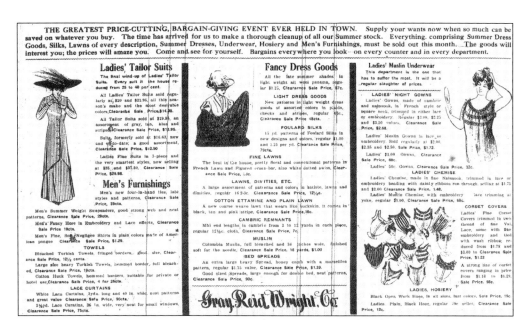

An advertisement from Gray, Reid, Wright, and Company printed in the *Carson Morning Appeal* features the most modern apparel for 1900. (Nevada State Library and Archives.)

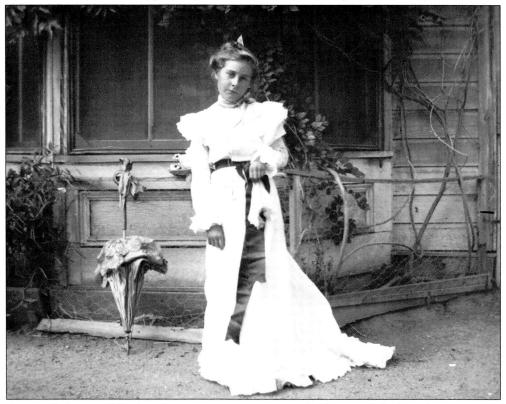

A young lady named Deck, in her pretty pouter pigeon-style blouse with high neck, is practicing for high society. The parasol and handkerchief prepare her for any eventuality. (Carson City Historical Society.)

Perhaps Deck purchased her outfit at Gray, Reid, Wright, and Company, who carried the most complete line of fashionable millinery and trimmed and untrimmed bonnets, as advertised in the *Carson Morning Appeal*. (Carson City Historical Society.)

According to the 1920 census, Jake Muller was living in Carson City with his wife, Bessie, and daughter, Julie. He was the local druggist. (Rolf and Gloria Johnson.)

Lyman A. Frisbie was born in 1835 and was in the Carson Guards in 1864. In 1870, he worked as a clerk in a saloon, was a musician, and had a band. The photographs on this page were taken by Carson City photographer C. A. Marston. (Rolf and Gloria Johnson.)

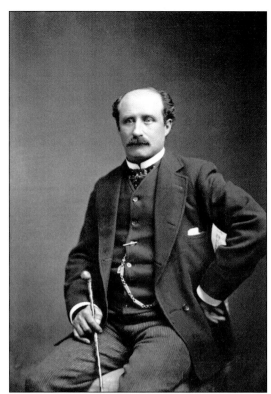

Mary Frisbie, wife of Lyman A. Frisbie, was born in Liverpool, England. She had two children, Fred and Walter. (Rolf and Gloria Johnson.)

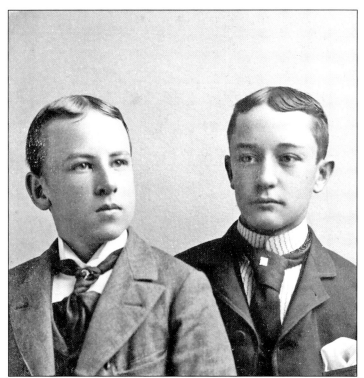

Horace and Ross Meder were the sons of J. P. Meder, who wrote many songs, including the "Hank Monk Schottishe," and was also the manager of the Carson Opera House. Horace (left) was born in 1881, and as an adult, he worked as an agent for the Virginia and Truckee Railroad in Minden. Horace owned the Rex Theatre and Smart Shop in Gardnerville in 1930. Ross Meder was born in 1876 and worked as a cashier in the Ormsby and Nye Bank in Carson City in 1904. (Left, Rolf and Gloria Johnson; below, Bancroft Library, University of California.)

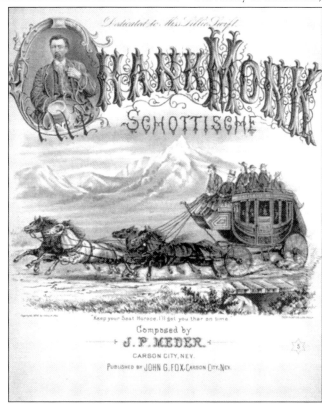

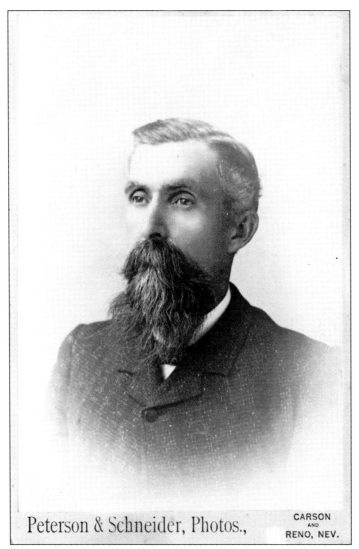

Peterson & Schneider, Photos., CARSON AND RENO, NEV.

Early Carson City photographers played a major part in the recording of history. Featured here is Dr. L. A. Herrick, who offered services as a homeopathic physician and surgeon. He had an office in the Savings Bank Building. He also ran for office, and on October 8, 1886, the *Morning Appeal* published the following:

In Ballo's Herrick claims to see
A remedy for all our ills.
But his majorities will be
A good deal smaller than his pills.

Said Garrard to Burke, "I've a strong desire
"To pull some chestnuts out of the fire."
And Haggerty queried of Overland Pat,
"Which is the Monkey, and which is the Cat?"

(Image courtesy of Rolf and Gloria Johnson.)

According to the 1920 census there were four people in William Prince Catlin's family: his wife, Ollie, his son, Prince E., and his daughter, Harriet. He was a mining engineer who graduated from the Nevada State University (now University of Nevada–Reno) in 1904 and had a strike at Silver Bow near Tonopah. His mine became part of the Catlin Silver Bow Mining Company. (Rolf and Gloria Johnson.)

Joseph Platt was born in Germany in 1843, and when he turned 16, he started for California. Like many before him, he crossed the Isthmus of Panama. He left California in 1862, established a clothing business, and spent his lifetime in Carson City. His store was in the Great Basin Hotel block, across from the state capitol. (Rolf and Gloria Johnson.)

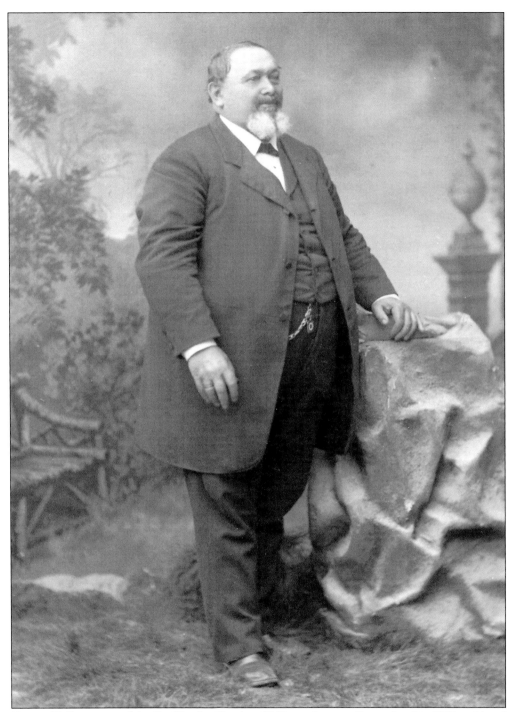

George Tufly, owner of the St. Charles Hotel in 1867, was born in Switzerland in 1817 and lived in Carson City with his wife, Sofia, and two girls. The St. Charles, also known as the Briggs House, was built by Tufly in the late 1860s. According to the *Carson Morning Appeal*, there were 48 guest rooms, "office, reading, writing room, and cuisine unexcelled by any moderate priced hotel in the State." (Rolf and Gloria Johnson.)

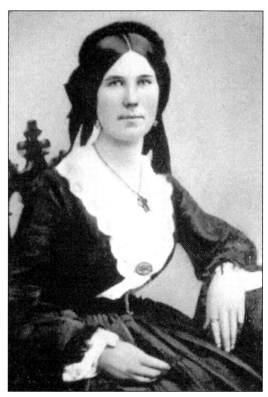

Annie Griffin Roberts was born in 1844 in Liverpool, England. She came to America when she was eight to be with her brother. She later married James Doan Roberts, and they had nine children, four of whom survived to adulthood. The surviving children (Richard, Mary, Josie, and Thurman) lived in the house at 1207 North Carson Street in Carson City. James Doan Roberts was born in 1826 in Virginia. In 1860, he fought in the Pyramid Lake War, and according to Thurman Roberts, his son, held Major Ormsby in his arms as he died. In 1864, J. D. Roberts leased the Lake House, a 50-room hotel in Washoe City, but the hotel burned in 1866. He then ran a saloon on E Street in Washoe City until 1872, when he moved the house and his family to Carson City. (Both, Carson City Historical Society.)

Nine

ENTERTAINMENT AND THE LEISURE HOUR CLUB

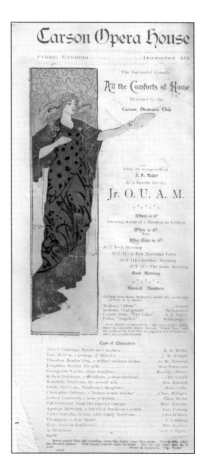

One of the priceless jewels of Carson City history is a scrapbook called the *Crazy Book* kept by Ed and Emma Vanderleith of the Leisure Hour Club, a Carson City institution founded in the 1890s. Starting in 1885, Ed Vanderleith (who was Gov. Roswell Colcord's private secretary), and his sister, Emma, collected mementos that were saved in this memory book. Here is a program from the Carson Opera House of the play *All the Comforts of Home*. The Leisure Hour Club, which had its beginnings in 1896, was organized at St. Peter's Episcopal Church in Carson City and continues today as an entertainment and learning club. Their motto is from Alfred Lord Tennyson's poem *In Memoriam*—"Let knowledge grow from more to more." (Leisure Hour Club.)

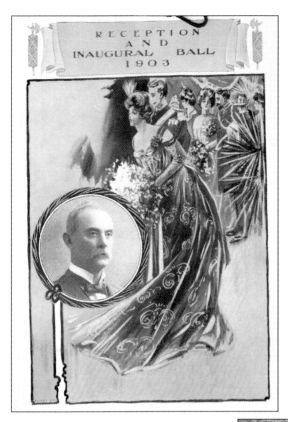

Gov. "Honest John" Sparks was born in Mississippi in 1843 and moved to Elko in 1881. In 1902, he was elected governor, and he was inaugurated in 1903. Sparks accompanied Pres. Theodore Roosevelt when he came to Carson City in May 1903. The years of 1907 and 1908 were particularly tough for him during the miner's strikes in Goldfield. He died on May 22, 1908, while still in office. (Leisure Hour Club.)

Leisure Hour Club members from Table No. 5 pose after the Calhoun Opera Company's presentation of *La Grande Duchesse*. In the center is Buddy Bliss, along with Clara Yerington, who won the women's first prize in the raffle, and Ed Vanderleith, who took the consolation prize. (Leisure Hour Club.)

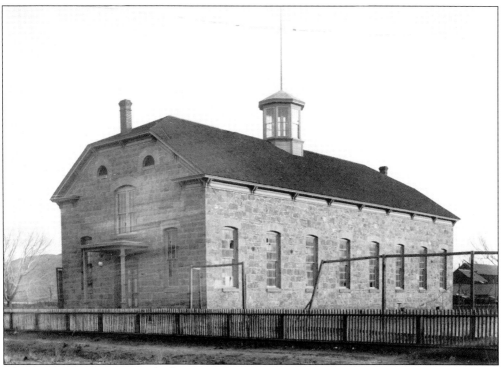

The armory in Carson City, the location of many community activities, is pictured around 1900. (Pat Cuellar.)

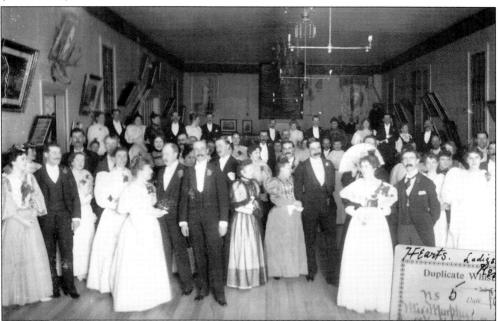

The Leisure Hour Club held many events and fund-raisers in Carson City, including a ball held at the armory, where the hall decorations were "the handsomest and most appropriate." The reception committee included A. M. Ardery, T. R. Hofer, H. D. Torreyson, and E. D. Vanderlieth. (Leisure Hour Club.)

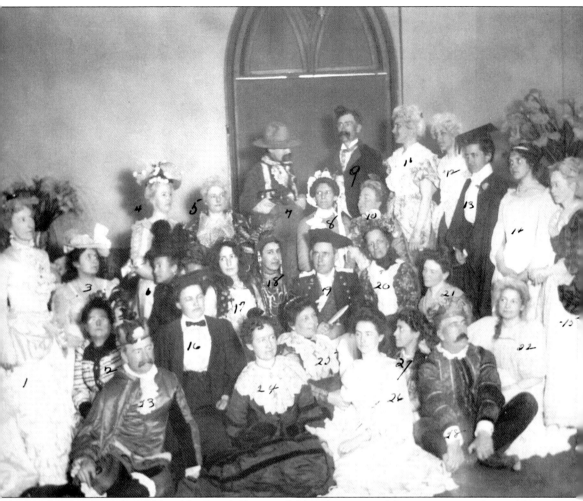

The Reverend B. Eddy of St. Peter's Episcopal Church organized five societies in Carson City, one of which was the Leisure Hour Club. He left to become dean of the Episcopal church in Salt Lake City. The Leisure Hour Club had a going-away party for him, and each member represented a person or character from literature. The following was sung to Reverend Eddy and his wife upon their departure on April 17, 1900:

"The night was filled with music, and the cares that infest the day
Folded in their tents like the pirates and silently stole away."

—*Carson Morning Appeal.* (Image courtesy of Leisure Hour Club.)

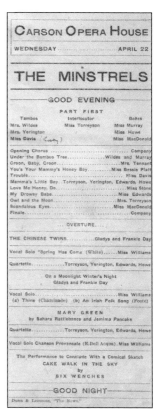

To raise money for a clubhouse, the Leisure Hour Club presented a minstrel show called the *Refined Darktown Lady Minstrels*. Held at the Carson Opera House, it had members of the Carson community as players. Ed Vanderleith sacrificed his beautiful mustache to take part in the show. The theatrical show raised $448 towards the $500 required to purchase the lot of the Leisure Hour Club House. It was enjoyed by the community members at that time but by today's standards would probably be regarded as racist. Pictured here is the troupe of the minstrel show, the cast of which included prominent citizens of Carson City. It should be noted that traveling minstrel shows were very common in the 1800s and early 1900s. (Both, Leisure Hour Club.)

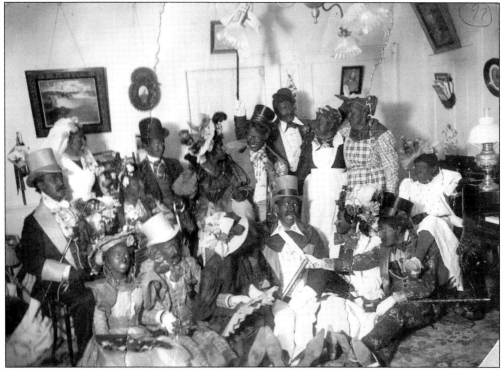

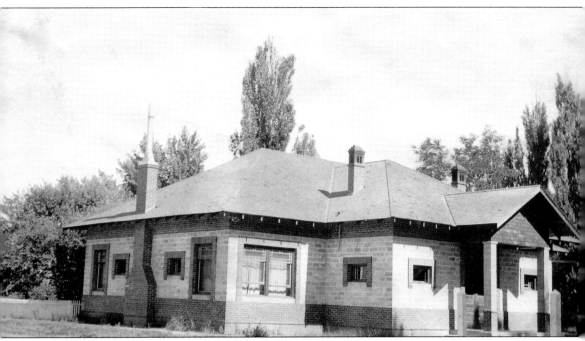

The cornerstone of the Leisure Hour Club Building, located behind the Presbyterian church, was laid in July 1913. The $5,500 cost of the building was raised through dues, selling shares, and events such as the minstrel show. Within the cornerstone was a copy of the Carson City *Appeal* of July 7, 1913, and uncirculated coins, including a silver half-dollar and a silver quarter, both dated 1913. (Leisure Hour Club.)

Ten

THE CIRCUS

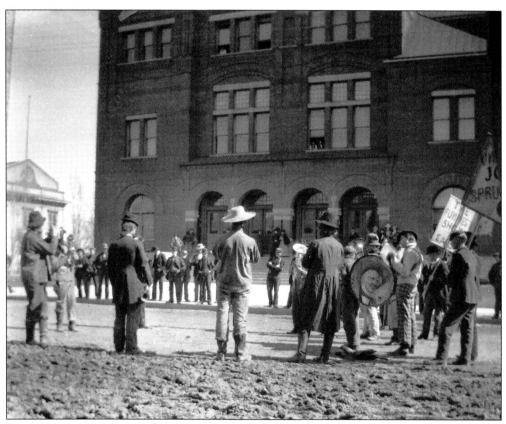

Part of Norris and Rowe's Circus was Uncle Josh Spruceby's Vaudeville act and the Hayseed Band, here performing a number in front of the federal building and post office (now the Paul Laxalt Building) in 1903. The founders of Norris and Rowe were Hutton S. Rowe, who entered show business as a balloon ascensionist and tightrope walker, and Andrew C. Norris, who was proprietor of a dog and pony show. (Pat Cuellar.)

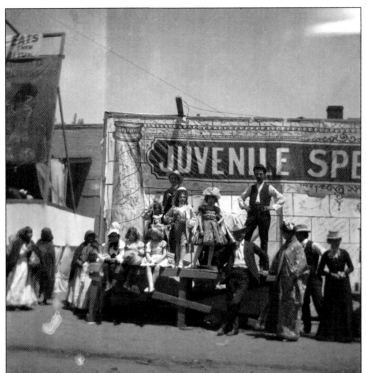

Across Carson Street, next to Gray, Reid, Wright, and Company, a "Juvenile Special" was taking place with young actors and actresses playing different roles. The sign above the tent says "Eats Them Alive." A true circus was in town. (Carson City Historical Society.)

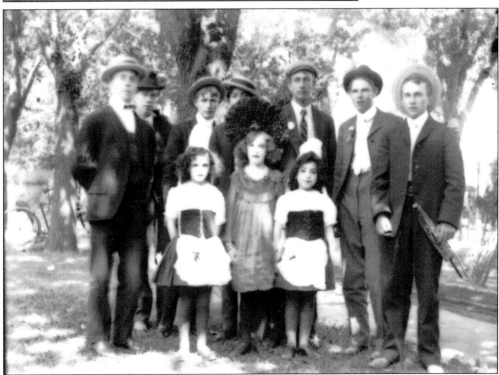

The young actresses and troupe pose for a group picture after the circus performance in 1903. (Pat Cuellar.)

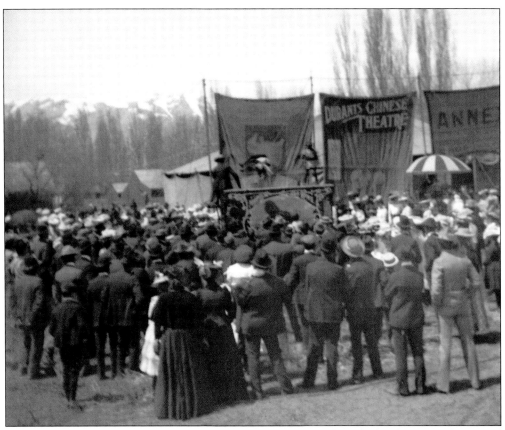

The "big top" was set up south of Carson City. As Alf Doten described in his journal on April 24, 1903, "The grand feature of today was Norris and Rowes great animal show—Big parade on street at noon—big 2,500 or 3,000 people house [tent] this PM, on grounds south of town, near the box factory [where Copeland's Lumber used to be on South Stewart Street] . . . 3 elephants, 2 llamas, 1 genuine camel, monkeys, dogs, et al.—Japanese acrobats, contortionists, etc.—Best show of the kind I ever saw." (Both, Pat Cuellar.)

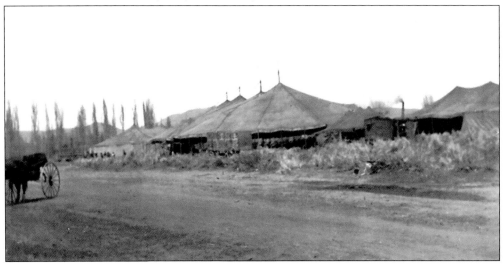

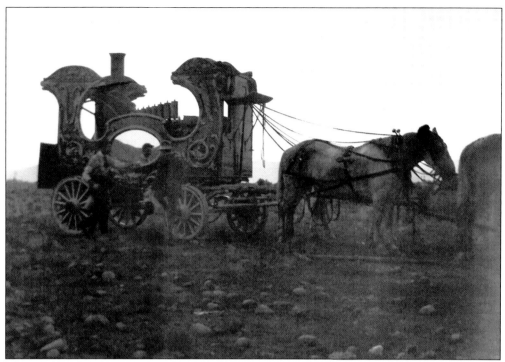

The Calliope sits outside of Carson City waiting for the big show. (Carson City Historical Society.)

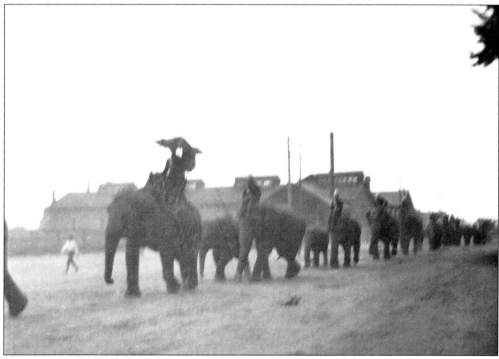

The elephants arrive. Norris and Rowe's Circus was known for its animals, and part of the show was the parade down Main Street. (Carson City Historical Society.)

Eleven

CORBETT-FITZSIMMONS FIGHT

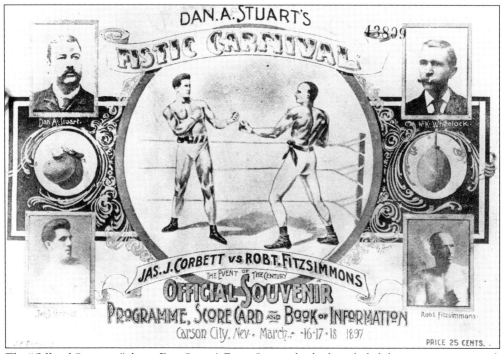

The "Official Souvenir" shows Dan Stuart's Fistic Carnival, which included the program, scorecard, and book of information for the fight between James J. Corbett and Robert Fitzsimmmons, Carson City, March 16–18, 1897. (Nevada Historical Society.)

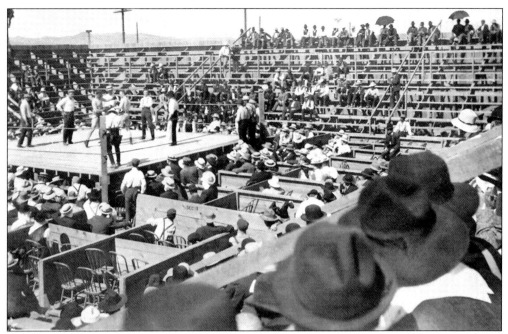

Above, fighters spar during a warm-up match in the Corbett-Fitzsimmons fight in Carson City, March 17, 1897. The governor and religious leaders opposed the legalization of boxing in Nevada, but legislation was signed into law allowing the matches. From the matchup came the first full-length motion picture filmed in Nevada, one quarter of which exists today. Gunfighter Wyatt Earp attended as a special reporter for the *New York World*. Bat Masterson was also in attendance. Note the gawker on the telephone pole at top left. Below, James J. Corbett reviews the Corbett-Fitzsimmons boxing ring with his wife prior to the fight. (Above, Pat Cuellar; below, Bernie Allen.)

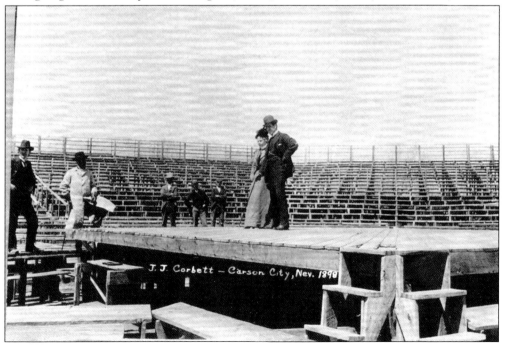

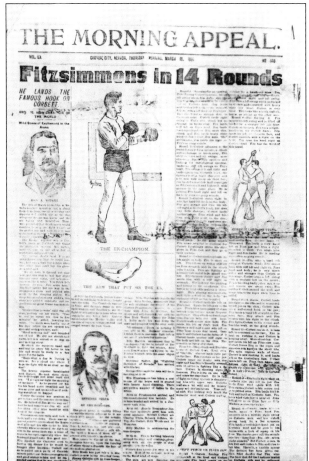

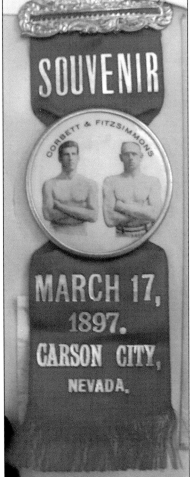

The *Morning Appeal* on March 18, 1897, reported: "Fitzsimmons wins in 14 rounds. He lands the famous hook on Corbett. The day started crisp, but warmed bringing out a bright blue Nevada sky." In attendance was "the fighting Governor of Nevada," Reinhold Sadler, with his young son. Another reporter, Nellie Mighels Davis, wrote: "I was reporting the fight from the feminine angle, for a Chicago paper and was paid $40 for the story. . . . I signed a fictitious name to the article, as I was afraid my friends in the east would read it and would be disgraced. . . . Only Fitzsimmon's wife and two girls from the red light district and myself represented the feminine element." A Corbett and Fitzsimmons souvenir ribbon and medallion is from the Carson City fight of March 17, 1897. (Above, Bernie Allen; left, Leisure Hour Club.)

DISCOVER THOUSANDS OF LOCAL HISTORY BOOKS
FEATURING MILLIONS OF VINTAGE IMAGES

Arcadia Publishing, the leading local history publisher in the United States, is committed to making history accessible and meaningful through publishing books that celebrate and preserve the heritage of America's people and places.

Find more books like this at
www.arcadiapublishing.com

Search for your hometown history, your old
stomping grounds, and even your favorite sports team.

Consistent with our mission to preserve history on a local level, this book was printed in South Carolina on American-made paper and manufactured entirely in the United States. Products carrying the accredited Forest Stewardship Council (FSC) label are printed on 100 percent FSC-certified paper.

MADE IN THE USA